POSTCARD HISTORY SERIES

Hyde Park

(Cover postcard) **THE MIDWAY PLAISANCE.** The Midway Plaisance was designed in 1871 as a landscaped boulevard connecting Washington Park and Jackson Park. In 1893, it achieved international fame as the amusement area of the World's Columbian Exposition and the site of the original Ferris wheel. This view, dating from the early 1900s, looks east. Buildings on the University of Chicago campus are visible at the left. (Raphael Tuck & Sons'.)

(Back postcard) **RYERSON PHYSICAL LABORATORY, UNIVERSITY OF CHICAGO.** Ryerson Physical Laboratory, built in 1894, was one of the University of Chicago's earliest buildings. It was designed by Henry Ives Cobb and paired with the equally ornate Kent Chemical Laboratory. Soon after it was built, University President William Harper declared it to be the most beautiful university building in the world.

POSTCARD HISTORY SERIES

Hyde Park

Leslie Hudson

ARCADIA

Published by Arcadia Publishing,
an imprint of Tempus Publishing, Inc.
Charleston SC, Chicago, Portsmouth NH,
San Francisco

Printed in Great Britain.

Library of Congress Catalog Card Number: 2003110954

For all general information contact Arcadia Publishing at:
Telephone 843-853-2070
Fax 843-853-0044
E-Mail sales@arcadiapublishing.com
For customer service and orders:
Toll-Free 1-888-313-2665

Visit us on the internet at http://www.arcadiapublishing.com

To My Parents

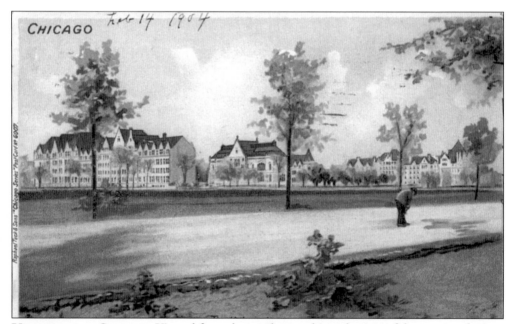

UNIVERSITY OF CHICAGO. Viewed from the southwest, this early view of the campus depicts, from left to right, Cobb Hall, the men's dormitories, Haskell Oriental Museum, Walker Museum, and the women's dormitories. (RTS-1904)

CONTENTS

ACKNOWLEDGMENTS

I would like to thank the following people for their assistance with this project: I am greatly indebted to the staff of the University of Chicago Special Collections Department, the staff of the University of Chicago Map Collection; my appreciation goes to Jay Mulberry and the Hyde Park Historical Society, archives which provided many answers and details; the Chicago Park District archives were extremely helpful—many thanks to Park Historian Julia Bachrach and Archivist Bob Middaugh; Gary Ossewaarde of the Hyde Park Kenwood Community Conference (and its website) provided answers to many questions about Washington Park and Jackson Park; my thanks to Manfred Ruddat of the University of Chicago for his help with the Botany Building history; Debra Gust and the Curt Teich Postcard Archives provided much useful information, as well as the Midway Gardens image; Samantha Gleisten at Arcadia Publishing provided assistance all along the way and the initial encouragement to write a postcard history of Hyde Park. My family has been supportive and interested throughout. I would like to thank Emily for her sound writing advice, Jack for his willingness to look at "just one more postcard," Dick for his good-humor and support, and Joan and Marje for manuscript improvements. Finally, I am grateful to the original recipients of these postcards, for saving them, and to the senders, whose messages often provided rich detail and insight into the period.

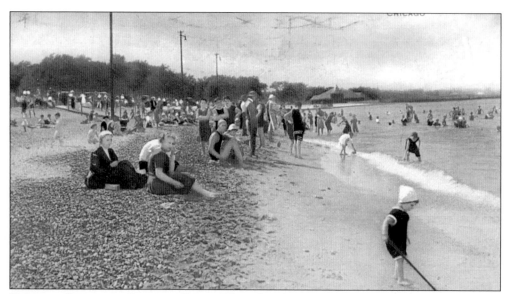

BATHING BEACH AT JACKSON PARK. These beach-goers are enjoying the waters of Lake Michigan at Hyde Park's 57th Street Beach. The beach pavilion, formerly the Iowa Building at the 1893 World's Columbian Exposition, appears in the background. (VOH-1916)

INTRODUCTION

Hyde Park is an especially appropriate subject for a postcard history book. Among Hyde Park's many claims to fame—host to the 1893 World's Columbian Exposition, location of the world-famous University of Chicago, site of the first controlled self-sustaining nuclear reaction, home to Nobel laureates and famous comedians—is a lesser-known distinction. Hyde Park was the birthplace of the picture postcard in America. The first picture postcards were sold from the top of the Eiffel Tower during the Paris Exposition of 1889 and were a great success. The World's Columbian Exposition, held in Hyde Park in 1893, followed the Paris example and printed a series of ten World's Fair views. Originally called simply "postals," or "Souvenir Mailing Cards," the little rectangles of cardboard soon became a national craze. In the years following the Fair, millions were printed, mailed and collected, with the peak in interest coinciding with the period of greatest growth for Hyde Park. The result is an abundant supply of images documenting the parks, hotels, amusement parks, and university buildings of Hyde Park as they looked in the early part of the 20th century.

Hyde Park's history began 40 years before the introduction of postcards, in 1853, with a land purchase by a young lawyer from New York. His name was Paul Cornell and the 300 acres of land he purchased, six miles south of downtown Chicago, he called "Hyde Park." He had a dream of a lakeside suburb and a formula to achieve it. He believed the following elements would ensure the community's success: good transportation, a tidy grid-like city plan, no (or only clean) industries, a church, a hotel, parks, and an institution that would provide stability for the community with steady employment for its residents. Except for the establishment of an institution (which didn't occur until 1890 when the University of Chicago settled in Hyde Park) all of the other elements came together in fairly short order, and Hyde Park flourished. In 1889, the village was annexed to the city of Chicago.

Cornell's greatest legacy, after the founding of the town itself, may have been his foresight in forming the South Park Commission and his choice of firms to design its parks. Cornell hired the successful landscape designers Frederick Law Olmsted and Calvert Vaux, planners of the highly-acclaimed Central Park in New York City, to draw up plans for the parkland adjacent to Hyde Park. Their report was printed and submitted in 1871, and included the design of a lakeside and interior park, with a connecting strip in between. The whole ensemble was called "South Park." In 1881, the separate divisions were formally named Jackson Park and Washington Park, although the term South Park continued to be used. Washington Park was developed first and its landscaping was completed in 1883. When Chicago was chosen to host the World's Columbian Exposition, Washington Park would have been a natural choice for the fairgrounds. The South Park Commissioners were concerned, however, that all their work and costly improvements would be destroyed by a fair and its attendant swarms of visitors. Olmsted, who had been hired to select the site and eventually design the grounds, preferred the lakeside location of the undeveloped Jackson Park and felt there were advantages to having a blank slate to work upon. For these and additional reasons, Jackson Park was selected as the site of the World's Columbian Exposition.

Rolling out his plans from 20 years earlier, Olmsted reworked his lagoon and island ideas into a design for the exposition grounds. He felt the natural setting of the waterways and island would complement and soften the massive exposition buildings planned for the Fair. The buildings themselves were designed by a team of architects who, in the interest of architectural harmony, had decided on a common building height and style. To unify the buildings even further, the buildings were painted white, which led to the

popular name for the World's Columbian Exposition—"The White City." Because of the temporary nature of their use, the buildings' exterior decorative surfaces were created with an inexpensive and easily sculpted material, a mixture of plaster, cement, and jute fibers, called "staff." The choice of style (Beaux-Art Classicism) and architects (mostly from the East) influenced American architecture for years to come. The Fair's architecture was well-received by the public, but viewed as a set-back for the architecture that had been developing in Chicago. Louis Sullivan, one of the few Chicago architects to design a major building for the Fair was especially outspoken. In later years he recalled one building in particular, the Illinois State Building, as "a lewd exhibit of drooling imbecility and political debauchery." In addition to its impact on architecture, the World's Columbian Exposition had other profound and long-lasting effects on the nation, ranging from ideas on urban design to the introduction of shredded wheat.

After the Fair ended, most of the structures were demolished or succumbed to fire. Besides the large exhibition halls, smaller structures had been built for states, foreign governments, and assorted lesser exhibits. A few of these smaller buildings and exhibits remained in Jackson Park as late as the 1940s. The Japanese Buildings, for example, remained on Wooded Island for many years and were much-admired. They are, in fact, believed to have influenced Frank Lloyd Wright in the development of his Prairie School style, which was fully expressed 13 years after the Fair in his design for the nearby Robie House. The German Building was turned into a park restaurant. The Life-Saving Exhibit became a U.S. Life-Saving Station and La Rabida Convent became a children's sanitarium. The Columbus ships remained moored in the motor boat harbor for many decades.

Hyde Park had established itself as a resort destination well before the World's Columbian Exposition. In 1857, Paul Cornell built a hotel called the Hyde Park House at 53rd Street and Lake Michigan, and among its guests were the Prince of Wales and Mary Todd Lincoln. The first attractions that drew visitors to Hyde Park were the lake and the escape Hyde Park provided from downtown congestion. Later, Washington Park, the beautifully landscaped Drexel Boulevard, and the Washington Park Race Track, built just south of Washington Park in 1883, enticed many Chicagoans south along Grand Boulevard (now Martin Luther King Jr. Drive) and Drexel Boulevards on what became a popular carriage circuit. In anticipation of the World's Columbian Exposition, many additional hotels were erected to accommodate Fair visitors. They remained after the Fair, as lodging for visitors to the later attractions as well as providing housing for residents. Looking at the community now it's hard to believe that Hyde Park was once a kind of Orlando, Florida, of its day. In the years following the World's Columbian Exposition, a number of amusement parks and attractions were established in south Hyde Park and Woodlawn, patterned after the successful Midway and World's Fair attractions. Most had failed by the end of the 1930s, but one has remained. The Museum of Science and Industry has survived and continues to be a tourist attraction on the scale of the greatest of Hyde Park's past.

Two weeks before the dedication of the World's Columbian Exposition, the University of Chicago held its first classes. The campus was under construction simultaneously with the construction of the Fair, and continued to be developed for many years after. Founded in 1890, the initial master plan for the campus was drafted by Henry Ives Cobb. His original plans set up the distinctive quadrangle-based campus, the site of the buildings, and the Gothic architectural style, and were followed for the next 40 years. Cobb continued as the University's architect and designed individual buildings until 1901. The architects who succeeded Cobb each interpreted the Collegiate Gothic style slightly differently and by the 1930s the style had taken on Art Moderne overtones. Despite these stylistic variations and the span of time involved, the buildings constructed in the University's first 40 years are remarkably harmonious and unified.

Hyde Park was well-represented in postcards. The postcards included here have been arranged by topic. I have included nearby buildings and sites in Woodlawn and Kenwood that would have been important in the lives of Hyde Parkers, or would have been visited by tourists coming to Hyde Park.

A statue in Hyde Park, entitled *The Fountain of Time*, has the following lines inscribed nearby:

"Time goes, you say? Ah no!

Alas, Time Stays, we go…"

Vintage postcards such as those presented here allow us a look at the past. We are fortunate to have them. I would like to acknowledge the senders of these postcards, and the incidental moments they preserved by the mailing of a card.

One
WASHINGTON PARK

"The finest of Chicago's parks. South Park has statelier trees, grander avenues, more sweeping perspectives, more charming drives than any other park in the city. It has the famous "meadow," a stretch of velvety sward that covers 100 acres and the "Mere," with its thirteen acres of water, picturesquely sparkling behind long lines of ancient oaks and elms, and bathing the emerald banks of the mounds and knolls which almost conceal it from the view of the passing visitor. It has also its great conservatory and its splendid stables, which cover 325 X 200 feet, and through which you will be driven if you take a park phaeton." (*The Standard Guide to Chicago*, 1893)

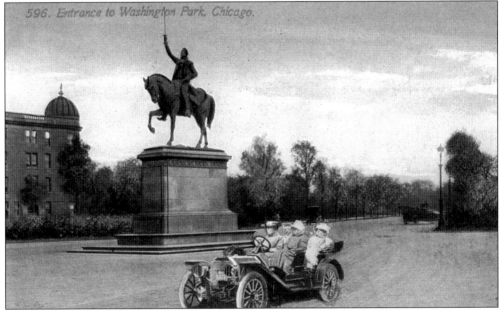

ENTRANCE TO WASHINGTON PARK. This equestrian statue of George Washington stands at the north entrance to Washington Park at Martin Luther King Jr. Drive (formerly Grand Boulevard) and 51st Street. Created in 1904, the statue is usually attributed to Daniel Chester French, who was also the sculptor of Abraham Lincoln at the Lincoln Memorial in Washington D.C. and Jackson Park's "Golden Lady." In fact, only Washington was the creation of French; the horse was the work of another sculptor, horse-specialist Edward Clark Potter. The two had collaborated on many sculptures for the 1893 World's Columbian Exposition. This is the second casting of this statue; the first is at the Place d'Iéna in Paris.

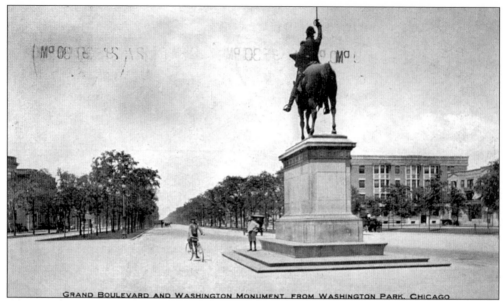

GRAND BOULEVARD AND WASHINGTON MONUMENT, FROM WASHINGTON PARK, CHICAGO

WASHINGTON MONUMENT AND GRAND BOULEVARD. Standing at this spot today, beside the Washington Statue and looking north up King Drive, one sees a view quite different from the empty and peaceful roadway depicted here. To accommodate the increase in automobile traffic, years ago the boulevard was widened to four lanes and the monument moved to a side median. The building visible to the right of the monument and the building in the previous view still stand. The message on the back reads: "This is the place for your Bicycle. Better come down am having a lovely time. Never had so many auto rides in my life. Lots to see but I miss home especially Baby Loretto. Love to all." (VOH-1910)

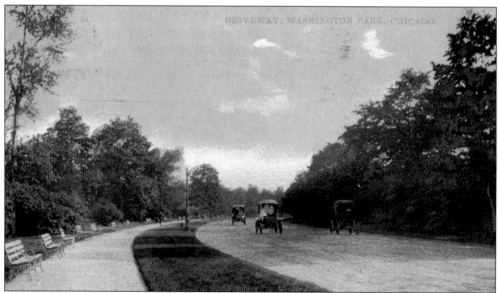

DRIVEWAY IN WASHINGTON PARK. Washington Park was encircled and bisected by curving roadways that remain today in basically the same configuration as when first laid out in the 1880s according to Olmsted and Vaux's plans. (1910)

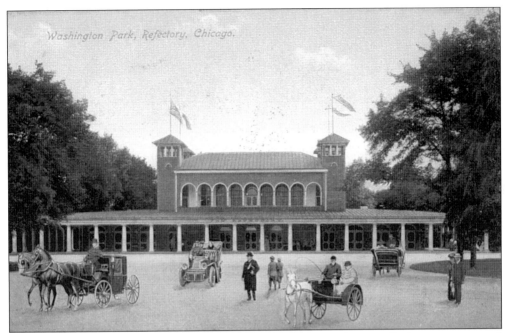

WASHINGTON PARK REFECTORY. The first restaurant in Washington Park was a converted house at 53rd Street and South Park Avenue (today's King Drive). Known as The Park Retreat, it served food and ice cream and was operated by the Park Commission. No "spirituous liquors," except light wines, were sold on the premises. In 1891 the building was torn down and this Refectory, designed by Daniel Burnham & Co, was constructed just south of Garfield Boulevard. A swimming pool was added on the south side of the building in the 1930s. The area in front of the Refectory where the carriages and automobile are standing was called the Concourse. (1910)

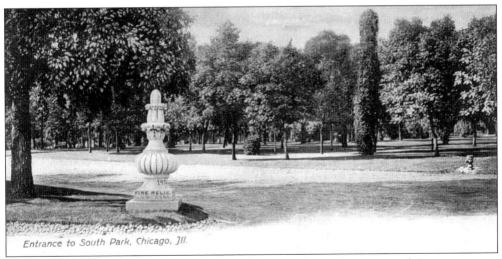

Entrance to South Park, Chicago, Jll.

ENTRANCE TO SOUTH PARK. Inscribed on this statue, located near one of the entrances to Washington Park, is "1871 Fire Relic." Apparently this piece of statuary or building ornament survived the Chicago Fire of 1871. Across the street from this statue, and the only other non-natural object in view, is a fire hydrant. (PS)

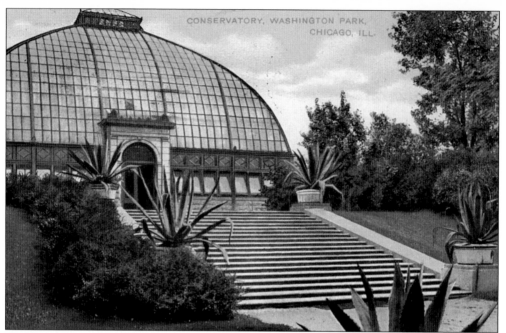

SOUTH ENTRANCE—WASHINGTON PARK CONSERVATORY. The Washington Park Conservatory, constructed in 1897, was located on the east side of Washington Park, along Cottage Grove Avenue at 56th Street. It replaced a smaller hexagonal conservatory on the same site that had been built in 1882. One of the many conservatories maintained in Chicago city parks at that time, the Washington Park conservatory enclosed 18,000 square feet of permanent and seasonal plantings, and its floral displays were considered especially beautiful. (SHK-1909)

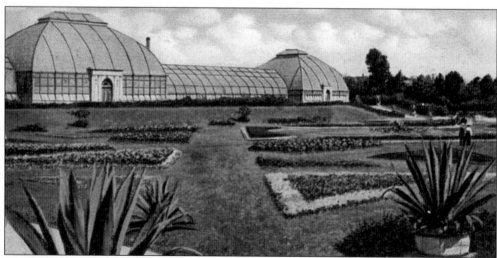

WASHINGTON PARK CONSERVATORY AND FLOWER BEDS. The sunken flowerbeds in front of the Washington Park Conservatory were renowned for their beauty. From *The Standard Guide* (1893) : ". . . but its flower gardens are its greatest boast, and here the visitor will pause the longest, for the angle in front of the flower house is probably the most seductive spot Chicago has to offer the lover of the beautiful in nature. . . . The designs are changed annually, are always original, always interesting and always lovely." (PAP-1909)

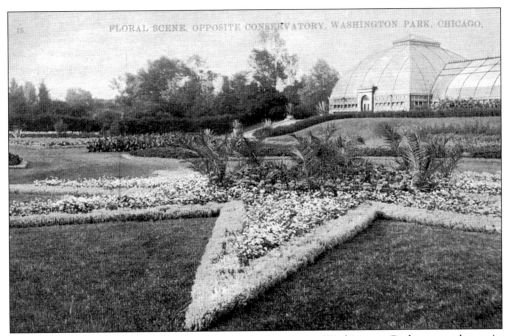

FLORAL SCENE. The following message was written on a Washington Park postcard sent in 1905: "This is one of the beauty spots of Chi. I think I like it even better than Lincoln Park, altho of course the latter is <u>the</u> park of the city."

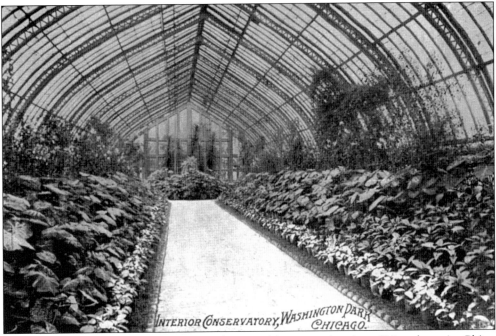

INTERIOR OF CONSERVATORY. The author on this postcard writes: "Have been in Chi. a week now. Will leave for home tomorrow. Was all thro' this conservatory. It's grand. Give my regards to Mr. White & the girls as well as yourself." (1911)

13

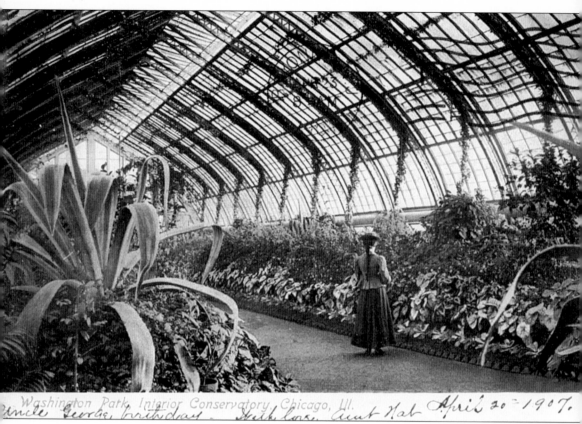

Washington Park, Interior Conservatory, Chicago, Ill. *Uncle George, birthday. With love. Aunt Nat* *April 20 = 1907.*

A VISIT TO THE CONSERVATORY. In 1910, the Conservatory was open every day of the year. It was especially popular on Sunday afternoons during the winter; weekdays, retirees and invalids reportedly took great pleasure from visits to it. Inside the conservatory, visitors strolled along red brick walkways viewing plants that were arranged on either side upon banks of earth, instead of the usual potting benches. In addition to spectacular floral displays, exotic desert and tropical plants were also exhibited. (AH-1907)

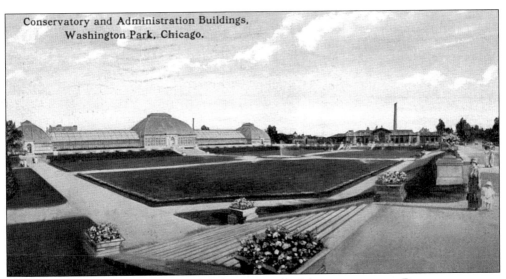

Conservatory and Administration Buildings, Washington Park, Chicago.

VIEW SOUTHEAST TOWARDS CONSERVATORY AND ADMINISTRATION BUILDING, AFTER 1910. The immense stack of the 1907 power building, which rises up behind the Administration Building in this view, still stands today. In 1911, the power plant generated the electricity for lighting Grand, Drexel, Oakwood, Garfield, and Western Boulevards, and all the parks except two. Soon thereafter the parks began purchasing current from the Sanitary District, which the power plant then transformed and distributed. Also visible in this view and still remaining in the park today are the concrete pier to the left of the woman and child in this view, the walkways, and the central staircase. The Conservatory, however, was removed from the park many years ago. (MRS-1914)

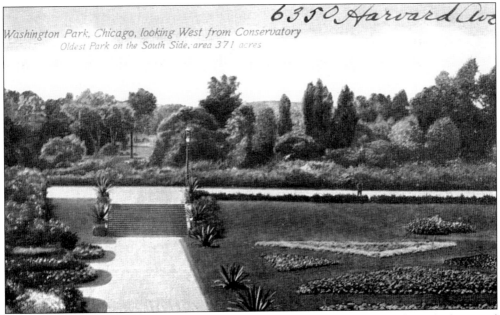

6350 Harvard Ave

Washington Park, Chicago, looking West from Conservatory
Oldest Park on the South Side, area 371 acres

VIEW WEST FROM THE CONSERVATORY. This view west looks across the flowerbeds toward the lagoons. The rose gardens were to the right, just out of view. (FP-1912)

15

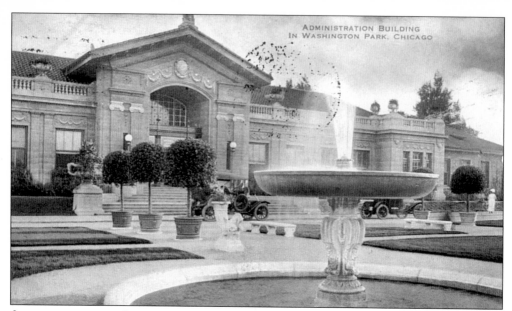

ADMINISTRATION BUILDING. The Administration Building for the South Park Commission was built in 1910. Like the Refectory and other buildings for the South Park District, it was constructed of poured concrete and was designed by the firm of D.H. Burnham. The DuSable Museum of African American History, founded in 1961, has occupied the building since 1973. An addition, built in 1992, contains additional gallery space and a theater. (VOH-1913)

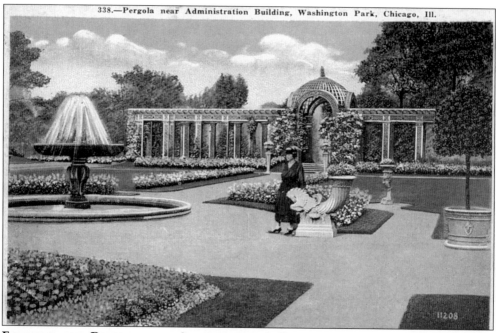

338.—Pergola near Administration Building, Washington Park, Chicago, Ill.

FOUNTAIN AND PERGOLA NEAR ADMINISTRATION BUILDING. These gardens were in front (to the north) of the Administration Building. (GB)

16

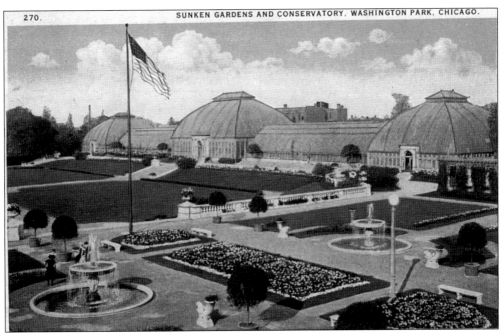

VIEW NORTHEAST FROM ADMINISTRATION BUILDING. Probably taken from the roof of the Administration Building, this photograph illustrates a later phase in the landscaping for this area. The floral beds in front of the Conservatory have been replaced by lawns and a central staircase to the Conservatory has been added. Note: The point of view of the previous card was beside the lamppost in the right foreground. (MRS-1926)

Washington Park, Chicago.

PERGOLA NEAR CONSERVATORY. This pergola appeared on many Washington Park postcards featuring the Conservatory which was located just to the left (north) of it, and in post-1910 postcards of the nearby Administration Building. (GB-1914)

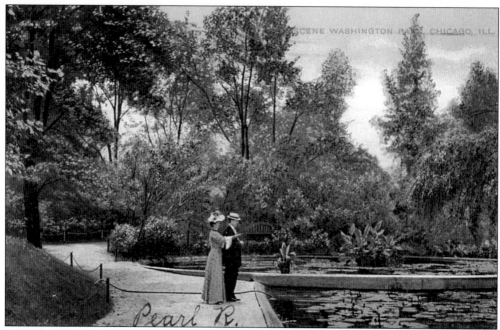

LILY POND SCENE. Lily ponds were a popular feature in most Chicago parks of the late 1800s and early 1900s. This couple is admiring the Washington Park lily pond, which was located near the conservatory. Built in 1880, it consisted of three connected basins that were originally heated with steam from the greenhouse boiler. (SHK-1908)

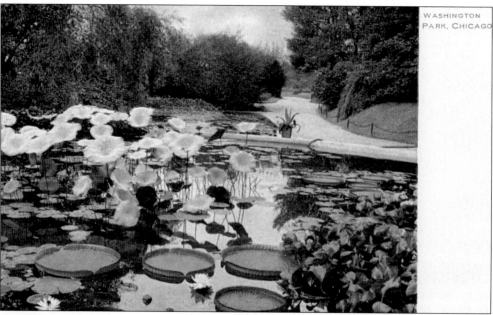

LILY POND. This postcard provides a close-up view of the pond above. In 1910, these lily ponds were destroyed when the Administration Building was erected on the site. (VOH)

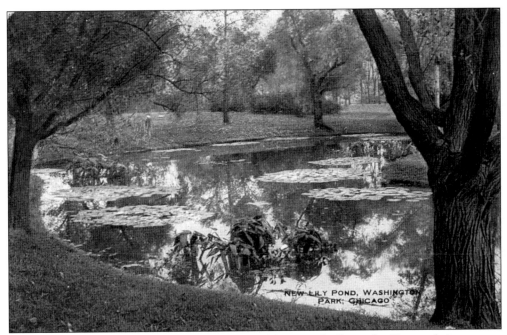

NEW LILY POND. After the Administration Building was built on the lily pond site, a new, more naturalistic lily pond was created in 1911 in the northeast section of the lagoon. A submerged dam kept the water level constant and steam provided heat. (VOH-1913)

STEPPING STONES NEAR RUSTIC BRIDGE. These stepping-stones were located just east of the Rustic Bridge (see p. 23). This picturesque view appeared on many Washington Park postcards sent during this period. On this card the sender wrote, "Having a dandy time. Heat hasn't killed me yet." (MRS-1914)

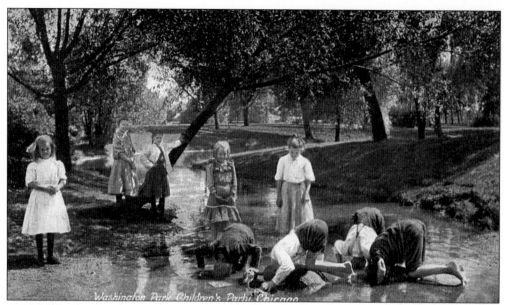

CHILDREN'S PARTY. The location of this postcard is not identified but it looks similar to the wading pool and spring area, east of the lagoon, in a part of the park now known as the Seven Hills. The boys are kneeling on stepping-stones but it's not clear what they're doing with their heads! (FP)

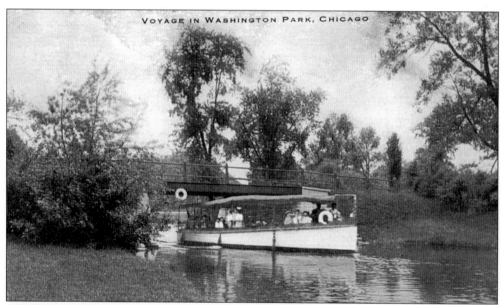

VOYAGE IN WASHINGTON PARK. Olmsted and Vaux's original 1871 South Park plans envisioned an extensive system of waterways in Jackson Park and Washington Park linked by a canal down the Midway Plaisance. As a cost-saving measure the linking canal was never constructed, but Olmsted's plans for waterways within the parks were carried out and boating was a major attraction at both Washington and Jackson Parks. This tour boat is passing under the Farmstead Bridge, which still stands today (with a different railing) at the south end of the lagoons. The view is looking southeast. (VOH)

Washington Park, Lagoon, Chicago.
Oldest South Side Park Area 371 Acres.

VIEW OF LAGOON. The location of this view is not identified but it was probably taken from the Rustic Bridge, looking northwest. Note: The streetlamp at right is identical to those used at the World's Columbian Exposition. (FP-1910)

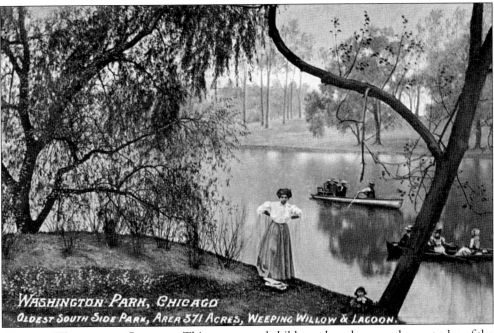

WASHINGTON PARK, CHICAGO
OLDEST SOUTH SIDE PARK, AREA 371 ACRES, WEEPING WILLOW & LAGOON.

WEEPING WILLOW AND LAGOON. This woman and child may have been on the west edge of the lagoon. A number of large weeping willow trees grow on the shoreline there today. (FP)

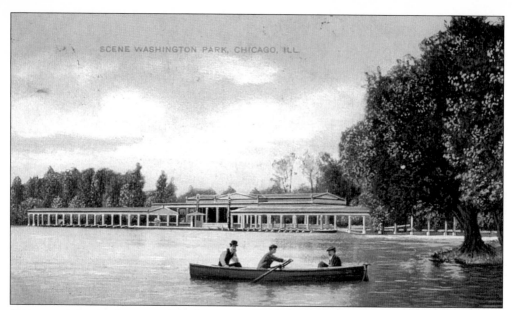

BOATHOUSE FROM LAGOON. The lagoons in Washington Park were first open for boating in the summer of 1883. This boathouse, located on the west side of the lagoon, was constructed in 1902 and was composed of a one-story main shelter and two boat shelters, one on each side of the main building. (SHK-1909)

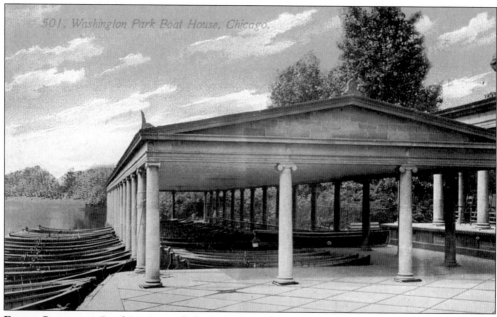

BOAT SHELTER. In this view of the left boat shelter (compare with above), the Greek Ionic-styling is apparent. The Boathouse was constructed of red concrete, included a kitchen and coatroom, and in the winter was used as a skating shelter. The boathouse was eventually demolished. Restoration plans for Washington Park include rebuilding a small boathouse on the site. (1911)

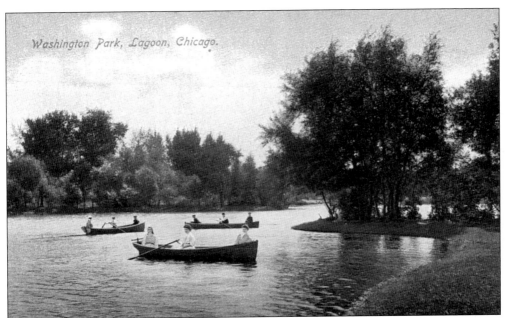

BOATING IN LAGOON. By 1906, 115 boats were in use in the park. Depending on their size, the rental rate for rowboats in 1909 was 15 to 25 cents per hour. This view appears to be from the boathouse, looking southeast.

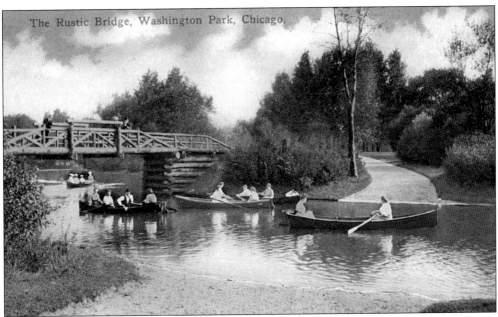

BOATING AT THE RUSTIC BRIDGE. Prior to 1904, the Washington Park lagoon was U-shaped and composed of two arms that came to within 90 feet of each other. To allow boaters to make a complete circuit without retracing their route, a channel was cut through the narrow neck of land that had separated the two arms. This created an island (now called Bynum Island) and the Rustic Bridge was built to provide access to it. Because the bridle path forded the waterway near this spot, the bridge was also sometimes called the Bridle Path Bridge. (1910)

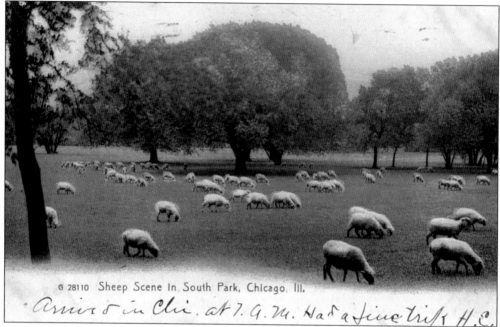

G 28110 Sheep Scene In South Park, Chicago, Ill.

Arrir ō in Chi. at 7. G. m. Had a fine trip H.C.

GRAZING SHEEP IN WASHINGTON PARK. Sheep were first introduced to Washington Park in the mid 1870s to add a picturesque element to the park and, additionally, to keep the grassy areas clipped. Beginning with 30 Southdown sheep, the flock was enlarged to 250 in 1877 but after three years the sheep were removed from the park entirely. In 1904, sheep were reintroduced to Washington Park and remained a feature of the park until 1920. "The meadow, with its flock of nibbling sheep, gives [the park] an especially sylvan appearance." (*Souvenir Guide to Chicago*, 1912) (R-1907)

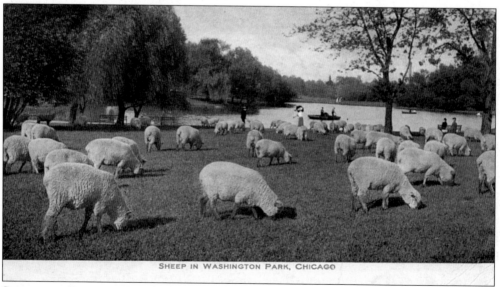

SHEEP IN WASHINGTON PARK, CHICAGO

SHEEP AND LAGOON. Caption on back reads: "Sheep Feeding in Washington Park. They are known to all the children in the vicinity and are very attractive to both young and old. They are owned by the Park Department and help them to keep the grass smoothly cut." (VOH-1908)

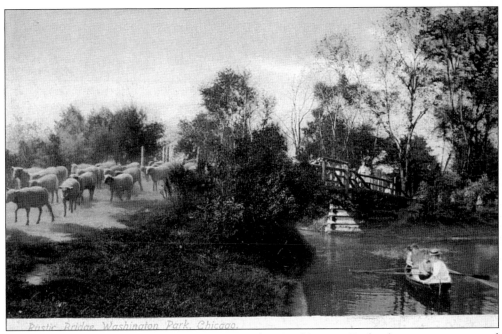

SHEEP CROSSING THE RUSTIC BRIDGE. The Washington Park sheep were pastured throughout the park and a shepherd was employed for at least a few years. A sheepfold, reached via the Rustic Bridge, was constructed on the island.

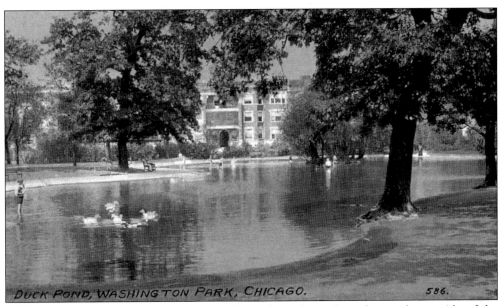

DUCK POND, LOOKING WEST. The Duck Pond was located on the northwest side of the park, between 52nd and 53rd Streets, where a playground is today. The half-acre pond originally featured two swans that were presented to the park by the Lincoln Park Commissioners. An ornate swan house was built on an island in the center. Some winters the pond was used for ice-skating and in the summer it served as a wading pool, as can be seen in this view. The Park Superintendent's house stood beside the pond for many years.

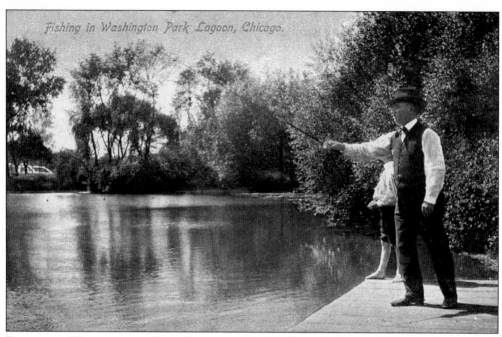

FISHING IN WASHINGTON PARK LAGOON. Not far from the Rustic Bridge, and east of the lagoon, was a pier and casting pond. The Rustic Bridge is visible to the left. (1908)

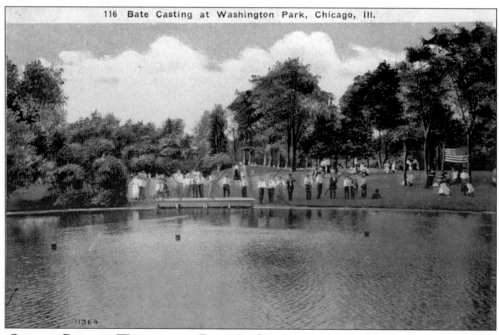

CASTING POND IN WASHINGTON PARK. In this view, perhaps of the same pier as shown above, bait casting targets float in the water. (GB)

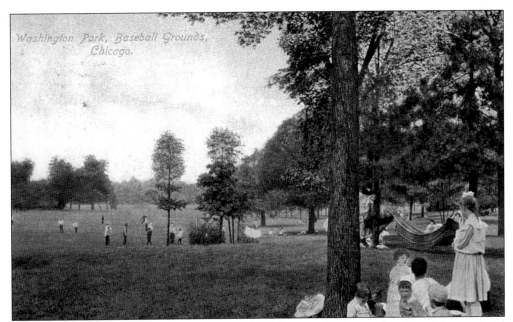

BASEBALL GROUNDS. The northern half of Washington Park was dominated by a central grassy area of 100 acres, which Olmsted called "The South Open Green." He created the uninterrupted expanse by locating all of the paths, driveways, and buildings along the perimeter of the park. In addition to accommodating the resident sheep, the area was used for baseball. In 1900, football and cricket fields were added. (FP-1908)

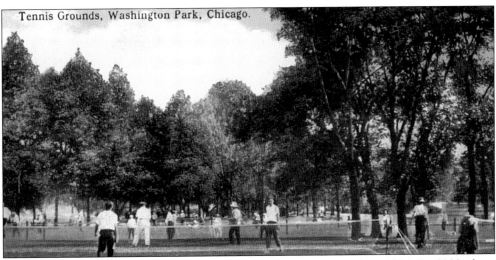

TENNIS GROUNDS. Lawn tennis first appeared in Washington Park in 1886. By 1900, there were a total of 42 tennis courts in Washington Park, the Midway, and Jackson Park. The courts were little more than nets strung up over uneven lawns, and the game played on them was perhaps more similar to badminton than to the tennis played today. The caption on the back reads: "Washington Park contains the largest Athletic Field in the world, the outdoor sports provided for including tennis, football, baseball, basketball, croquet, bowling and archery. Permission for athletic contests of all kinds by amateurs may be had on application and all sports are conducted under rules of the Park Board." (MRS)

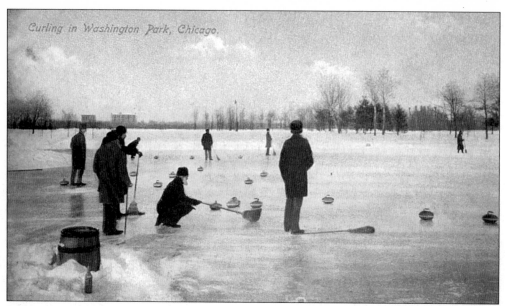

Curling in Washington Park, Chicago.

CURLING IN WASHINGTON PARK. Winter activities offered at Washington Park included tobogganing, ice-skating, and curling. A 36-foot high toboggan slide was built in the park in 1908 and operated for several winters. Sleds holding six to ten passengers were rented for 25 cents an hour. Curling and ice-skating were enjoyed on the frozen lagoons and ponds. Only the distant buildings and streetlamps reveal that this is an urban scene. Note warming spirits which stood, at the ready, in the foreground.

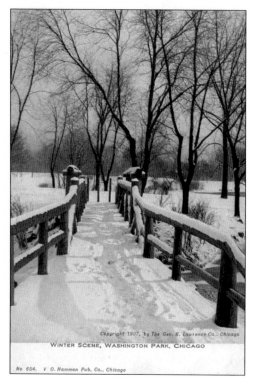

Copyright 1907, by The Geo. E. Lawrence Co., Chicago
WINTER SCENE, WASHINGTON PARK, CHICAGO
No 654. V O. Hammon Pub. Co., Chicago

RUSTIC BRIDGE IN WINTER. This is an uncommon scene; winter was rarely depicted on early Chicago postcards. (VOH-**1907**)

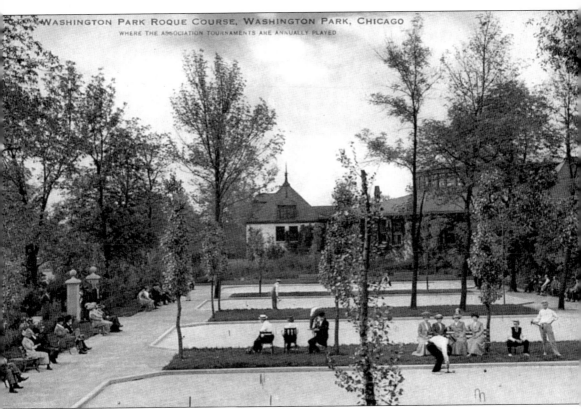

ROQUE COURTS. The game of roque arose in the United States as a variation of croquet. The name was created by dropping the first and last letters from "croquet." The game is similar to billiards, in that balls can be caromed off the raised borders that enclosed the hard-surface court. The rules were standardized in 1899 and for a brief period the game was more popular than croquet. Washington Park's six roque courts existed into the 1930s and were located directly south of the stables (still standing), which can be seen behind the roque courts in this view. (VOH)

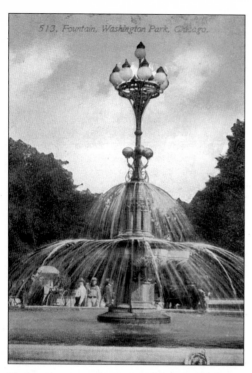

FOUNTAIN ENTRANCE TO WASHINGTON PARK. This fountain, located at one of the entrances to Washington Park, not only beautified the park but also provided a source of drinking water for horses. Horses can be seen drinking on the far side of fountain in this view; after stopping for water at the Grand Boulevard fountain at 35th Street (see p. 118) perhaps this was the next drinking opportunity for horses making the circuit from downtown. (A)

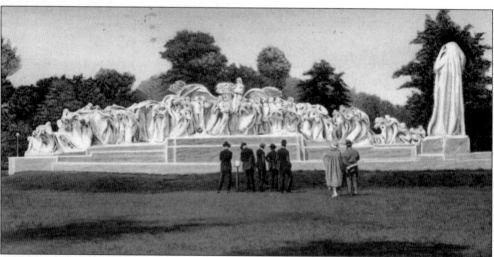

FOUNTAIN OF TIME. Chicago sculptor Lorado Taft was commissioned to create this sculpture to commemorate 100 years of peace between the United States and Great Britain resulting from the 1814 Treaty of Ghent. The sculpture takes its inspiration from a poem by Austin Dobson: "Time goes, you say? Ah no! Alas, Time stays; we go. . . ." From across a reflecting pool, Father Time surveys a wave-like procession of humanity. Taft included himself in the assembly as the smocked figure on the west side. Concrete was chosen as the material because of climate and budget constraints (which precluded the use of marble and bronze, respectively). The work is said to be the largest multi-figured sculpture on a single base in existence, and the first use of concrete as an artistic medium. It was dedicated on November 15, 1923. Restoration of the sculpture was completed in 2002. (CT-**1933**)

Two
JACKSON PARK

"Jackson Park is unsurpassed anywhere for beauty, having the advantages of ample space, the blue waters of Lake Michigan for a foreground, a natural growth of trees and the aid of the best landscape gardeners' art to bring all into harmony. . . .Those who came to Chicago in 1893 will always associate this park with the surpassingly beautiful group of buildings which were a part of the Columbian Exposition. . . .The beautiful lagoons of Jackson Park, in one of which is the Wooded Island, are worthy of special mention. . . . Every effort is made by the Park Commissioners to make this park not only beautiful, but thoroughly serviceable to all who enjoy outdoor exercise and sports. There are no "Keep off the Grass" signs." (*Guide to Chicago*, 1909)

FIELD MUSEUM, FROM THE NORTHWEST. This early view of Jackson Park features the only structure which remains today from the World's Columbian Exposition. Originally an art exhibition hall called the Palace of Fine Arts, after the Fair the building was a repository for some of the anthropological and natural history exhibits remaining from the exposition. These exhibits were the germ of the Field Museum collection, which was expanded and exhibited in the building until 1920. The building took on its final incarnation in 1933 when it was remodeled and opened as the Museum of Science and Industry. (RTS-1906)

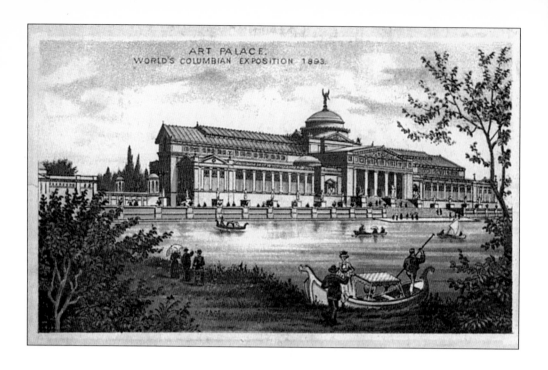

ART PALACE.
WORLD'S COLUMBIAN EXPOSITION 1893.

PALACE OF FINE ARTS. This card is from a series entitled "World's Fair Views," inserted for a limited time into packages of coffee. The back of each card provided a detailed description of the view (at left). Distributed during the course of the Fair, these and other trade cards helped satisfy the public's curiosity about the World's Fair being held in Chicago. This view depicts the Palace of Fine Arts from the southwest, with the lagoon in the foreground. Charles B. Atwood designed the building, and many of its classical elements were taken from buildings on the Acropolis. Atop the dome can be seen a statue entitled "Winged Victory." It was removed shortly after the Fair opened and does not appear in most photographs of the building.

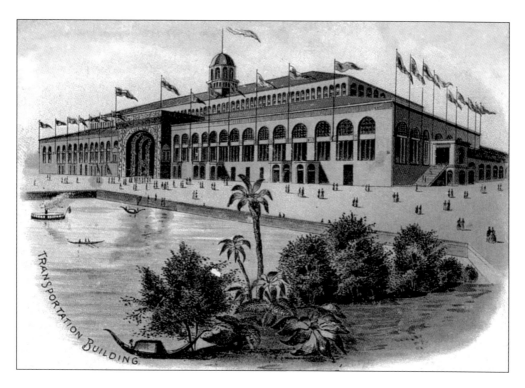

TRANSPORTATION BUILDING. The Transportation Building deviated from the standard program of white Classicism employed to unify the other buildings. Designed by architects Dankmar Adler and Louis Sullivan, the building was painted over 30 different shades of red, orange, and yellow, and took its design inspiration from Byzantine and Islamic sources. Most striking, however, was its incredibly ornate golden doorway. The question most frequently asked among early visitors to the Fair was, "Have you seen that golden doorway yet?" This trade card for a Chicago chewing gum company may have been passed out on the fairgrounds (reverse side below).

BORG'S SURE CURE

CHEWING GUM,

PEPSIN and BISMUTH.

There is nothing better known to Medical Science for the Cure of Indigestion, Dyspepsia and Heartburn than Pepsin and Bismuth.

Manufactured by F. BORG,

59 AND 61 CANAL STREET,

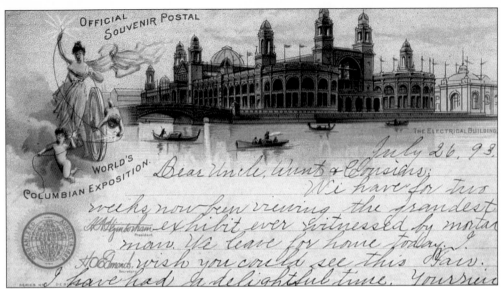

THE ELECTRICAL BUILDING. The first postcards used in the United States were a series produced for the World's Columbian Exposition, including this postcard of the Electrical Building. The challenge of exhibiting this nascent technology can be seen in the following quote from the *Official Guide to the Fair*: "[T]he Electrical has a peculiar novelty and freshness in the popular mind. . . . The rapidity of Electrical development finds no parallel in any other range of discovery . . . the science of electrical development has advanced just far enough to teach the electricians that they are merely on the threshold of unbounded worlds of knowledge. The present exhibit, marvelous as it stands . . . may prove to have been crude and insignificant before rounding out of the present century." (CWG-**1893**)

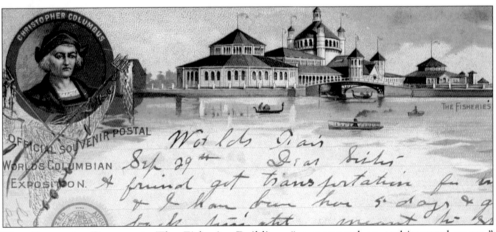

THE FISHERIES BUILDING. The Fisheries Building, "pronounced an architectural poem," according to the *Official Guide*, was designed by Henry Ives Cobb. At this time Cobb was also architect for the University of Chicago, under construction nearby. The exterior ornamentation of the Fisheries Building realistically depicted fish and other marine forms. A highlight of the interior was a beautiful anemone grotto. Early plans called for the display of a live whale but this was abandoned and live sharks were exhibited instead. A fish restaurant on the upper level was intended to demonstrate the value of fish as a food; at the time, fish was not yet commonly served in the Midwest. (CWG-**1893**)

Ferris Wheel. The giant wheel at the World's Columbian Exposition was engineer George W. Ferris's response to the challenge put to American engineers to top the achievement of Gustave Eiffel at the Paris Exposition of 1889. The first Ferris wheel ever, many were skeptical until it was built and operating that it wouldn't destroy itself due to physical forces caused by its rotation, or collapse because of its weight. Unbelievably huge, it had 36 cars which held 60 passengers each, and rotated on a 45-foot-long axle which was the largest single piece of forged steel in the world at the time. It stood at nearly twice the height of the Ferris wheel currently at Chicago's Navy Pier. In September 2000, a crew excavating for the construction of an ice-skating rink and warming house on the Midway Plaisance uncovered large timbers (one described as "literally a tree trunk") and concrete. Discovered about four feet underground, these were remains of the foundation of the 1893 Ferris Wheel.

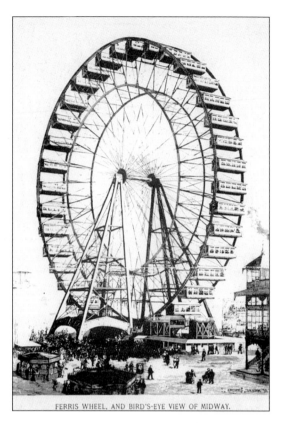

FERRIS WHEEL, AND BIRD'S-EYE VIEW OF MIDWAY.

Magic Lantern EXHIBITION. Admit Bearer.

Magic Lantern Exhibition Ticket. Another Midway attraction, the Magic Lantern Exhibition was displayed in the "Zoöpraxographical Hall." This hall was, in effect, one of the first movie theaters ever. Inside was Eadweard Muybridge's "zoöpraxiscope" which projected very short-duration moving images of animal locomotion such as galloping horses and somersaulting athletes. It was accompanied by a scientific lecture. Having to compete with the adjacent Ferris wheel and the popular Streets of Cairo, it was not a commercial success. Perhaps the "zoöpraxiscope" would have received the attention it deserved in one of the Fair's loftier venues, such as the Manufacturers and Liberal Arts Building.

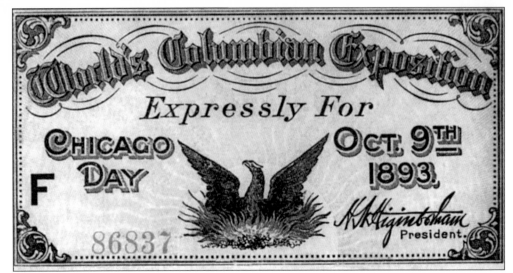

CHICAGO DAY TICKET. In an attempt to boost attendance, the Fair's organizers scheduled special days to honor nations, states, and organizations. October 9th, 1893, the 22nd anniversary of the Chicago Fire, was set aside as Chicago Day. Attendance exceeded 700,000, which at the time was the largest number of people ever assembled for a single day event in the history of the world.

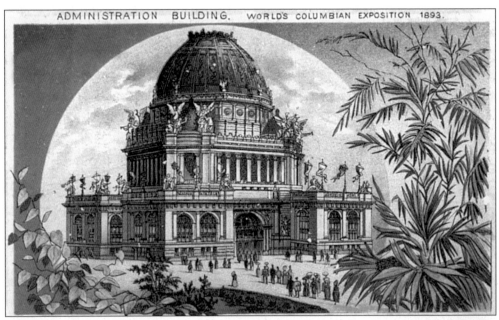

ADMINISTRATION BUILDING. The Court of Honor was the focal point of the World's Columbian Exposition, and commanding the Court of Honor was the Administration Building. Designed by Robert M. Hunt, it was the most expensive building in the Court (in cost per square foot) and its gilded dome could be seen shimmering over the fairgrounds and for many miles out in Lake Michigan. Today, Jackson Park's Statue of the Republic ("The Golden Lady") stands on the site of the Fair's Administration Building.

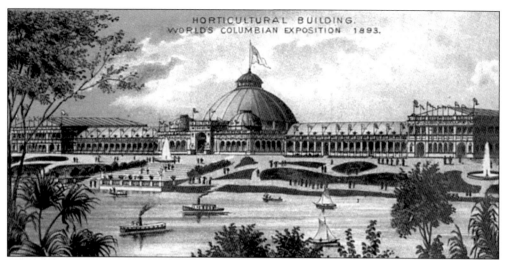

HORTICULTURE BUILDING. The Horticulture Building, designed by the firm of Jenney and Mundie, was composed of eight greenhouses covering over five acres. Inside, beneath the large central dome, was a miniature mountain with a flowing stream and covered with palms, ferns, and bamboos ("an immense pyramid of shrubbery"). Beneath the mountain visitors could enter the Crystal Cave, or visit a darkened room with the Mushroom Bed exhibit. As reported in the *Official Guide*, orchid specimens "were collected in Mexico and Central America and transported, still clinging to the original branches and bark." Outside, "the bed to the north has created a revolution in the pansy world . . . [displaying] a new creation of immense and richly-colored flowers."

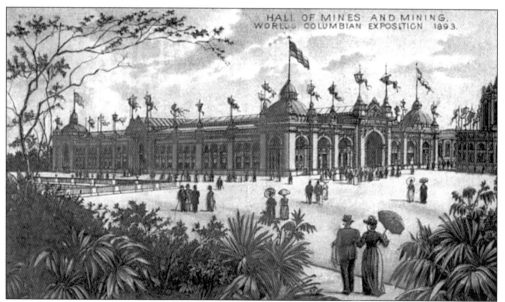

HALL OF MINES AND MINING. The Hall of Mines and Mining included exhibits of gems and precious metals, stones, soil, and "exceptional" displays of coal and iron. Architect and critic Henry Van Brunt observed that the building's exterior massiveness reflected the coarseness of the ores and minerals displayed within; the building was not well-received by the public. The architect was S.S. Beman.

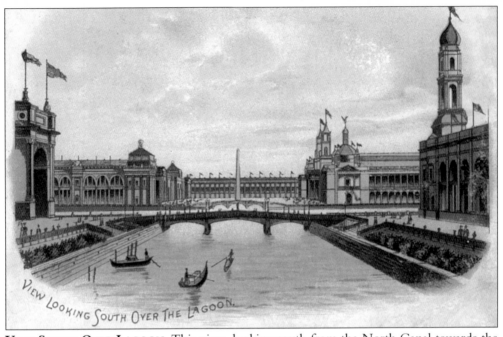

VIEW SOUTH OVER LAGOON. This view, looking south from the North Canal towards the obelisk in front of the Stock Pavilion, perpendicularly crosses the main axis of the Court of Honor. In the foreground, left, is a corner of the Manufacturers and Liberal Arts Building and on the right, the Electrical Building.

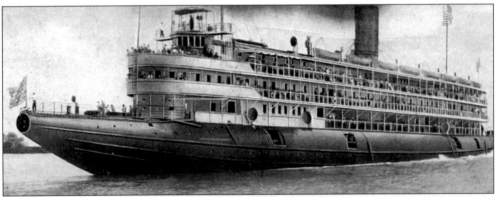

WHALEBACK STEAMER "CHRISTOPHER COLUMBUS." Built to ferry passengers between downtown (Van Buren Street) and the Fair (67th Street), the Christopher Columbus arrived for operation in Chicago on May 18, 1893. Based on a novel design used previously only for freight steamers, passengers rode on a double deck supported over a cigar-shaped hull. "It may be seen, however, that on a rolling sea the passenger will be seriously disturbed, and on one trip from the park to the city ninety people were ill, and fifteen of them could not be immediately removed on reaching the docks." (from *The Dream City*, 1893*).* Despite this flaw, the Christopher Columbus continued to operate for the next 40 years, making roundtrips between Chicago and Milwaukee. In 1910, the sender of this postcard wrote: "I was awful sick after I came home from Milwaukee. This is the boat we made the trip on. Sadie was so sea sick she nearly died but I was alright till I got here . . . We was on the lake all night in the worst storm you ever heard of." (FP-1910)

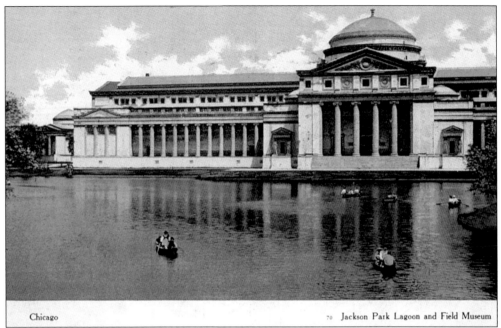

Chicago

FIELD MUSEUM (FORMER PALACE OF FINE ARTS). In 1894, the Palace of Fine Arts was renamed the Field Museum after its benefactor, Marshall Field, who was inspired to sponsor the museum, with an initial contribution of $1,000,000, at the urging of fellow Chicagoan William Ayer. Ayer initially angered, but eventually persuaded Field, with the comment that true immortality did not come to men who sold dry goods. A museum, he argued, would etch Field's name in stone. (CT-1908)

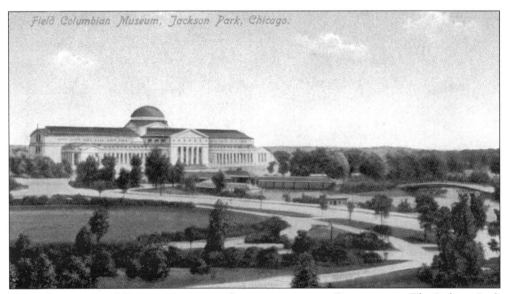

Field Columbian Museum, Jackson Park, Chicago.

FIELD COLUMBIAN MUSEUM FROM THE SOUTHWEST, WITH BOATHOUSE. The Jackson Park boathouse and boat launch are visible beside the lagoon in this view of the south façade of the Field Columbian Museum. A bridge to Wooded Island can be seen to the right. In the foreground is the eastern end of the Midway Plaisance.

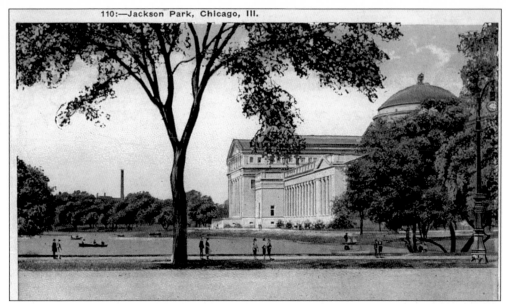

FIELD MUSEUM FROM THE SOUTHEAST. Because this building was designed to exhibit valuable works of art, the interior walls were constructed of fireproof materials. This enabled the building to remain as a permanent structure in Jackson Park after the Fair. The museum's first anthropological and natural history artifacts were obtained from former World's Columbian Exposition displays. (GB)

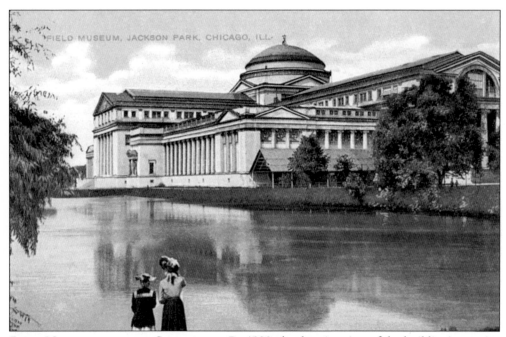

FIELD MUSEUM, JACKSON PARK, CHICAGO, ILL.

FIELD MUSEUM FROM THE SOUTHEAST. By 1920, the deterioration of the building's exterior (which had been covered with staff, the impermanent material widely used for the other World's Columbian Exposition buildings) had prompted the construction of a new building downtown, and the Field Museum moved to its present location. (SHK)

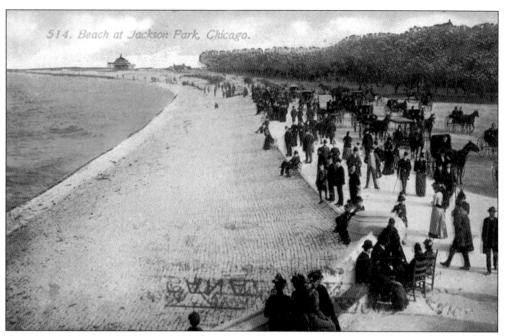

BEACH AT JACKSON PARK. The Jackson Park beach, created in the 1880s, extended from 56th to 59th Streets. It was later paved, from 56th to 63rd Street, with granite blocks which are visible in this view. (A-1913)

GERMAN BUILDING AND BATHING BEACH. The German Building, was another remnant from the Fair and was one of many exhibits contributed by Germany. Germany felt it had been under-represented at the earlier international expositions, and made sure that didn't happen again. "The total number of German exhibitors amounts to over 5,000. Its displays range from that of the Krupp Gun Company down to the smallest manufacturers of hosiery and gloves. There are represented 230 cities and towns, and of these, 40 cities send more than ten exhibits each. Berlin leads with 283 exhibitors. . . . The German building is one of the most beautiful of the foreign structures, and her pavilion in the Manufacturers building in unsurpassed." (*The Guide to the Fair*, 1893) (MRS)

GERMAN BUILDING FROM JACKSON PARK BEACH. In the years following the World's Columbian Exposition, the German building served as a park refectory, as described in the *Guide to Chicago*, 1909: "The Park Refectory, unique as containing a restaurant which is run by the park commissioners, is located near the lake front in the central portion of the park. Light refreshment at reasonable prices may be obtained. This was the German Government Building during the exposition." (GB)

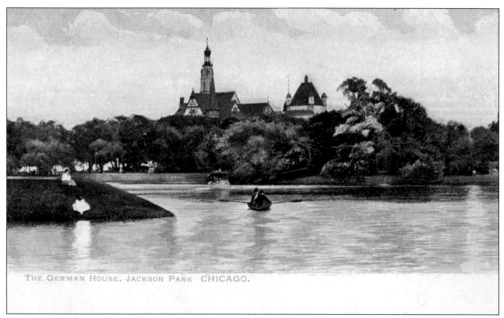

THE GERMAN HOUSE, JACKSON PARK CHICAGO.

GERMAN BUILDING FROM THE NORTHWEST. The German Building provided a picturesque focal point for many early Jackson Park postcards. (ECK)

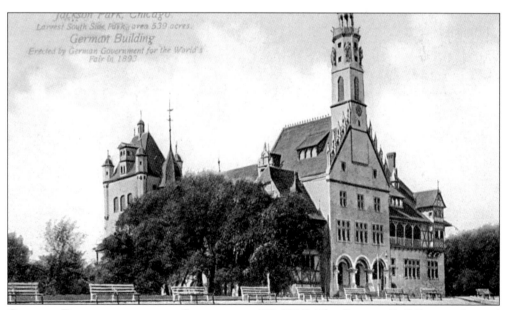

Jackson Park, Chicago.
Largest South Side Park; area 539 acres.
German Building
Erected by German Government for the World's Fair in 1893.

GERMAN BUILDING FROM THE SOUTHEAST. (FP-1911) The German Building was located on the 57th Street Beach, southeast of the Field Museum, on what is now the site of the lawn bowling green. (FP-1911)

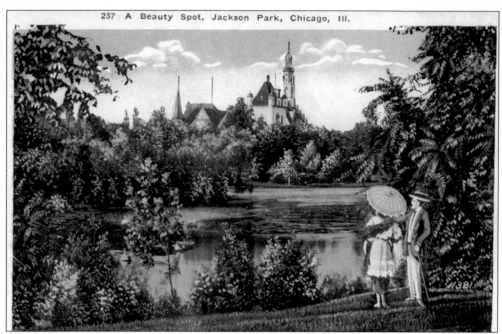

237 A Beauty Spot, Jackson Park, Chicago, Ill.

BEAUTY SPOT IN JACKSON PARK. The German Building and lagoon are seen here viewed from the southwest. (GB)

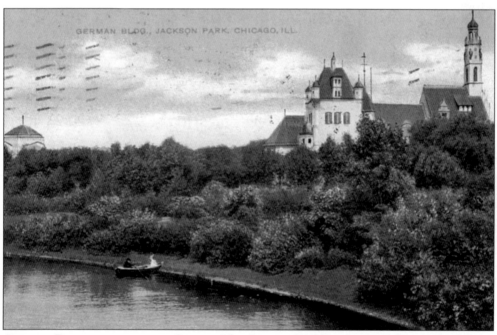

GERMAN BLDG., JACKSON PARK, CHICAGO, ILL.

GERMAN BUILDING FROM THE SOUTH. The German Building continued to serve as a park refectory until 1926, when it was destroyed by fire. (SHK-1908)

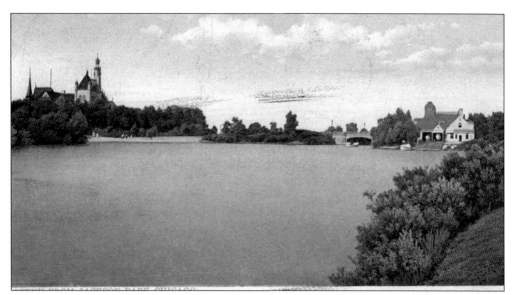

LAGOON, WITH GERMAN BUILDING AND LIFE-SAVING STATION. The German Building appears to the left of the Lakeshore Boulevard bridge (see p. 63) and the Life-Saving Station (see below). Postcard collecting was at its height of popularity at this time as can be observed in this sender's message: "I will send some of one place at a time then you won't get two alike. In this place is where they boat ride." (BS-1909)

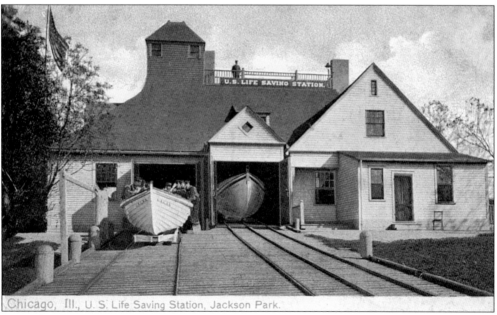

Chicago, Ill., U. S. Life Saving Station, Jackson Park.

LIFE-SAVING STATION. This building was another holdover from the World's Fair, and is described in the *Guide to Chicago* (1909): ". . . the United States Life Saving Station is near the lake shore and faces one of the park lagoons. This was one of the interesting features of the U.S. Government exhibit at the Fair and ever since then has been maintained as one of the regular life saving stations on the same basis as others which at intervals of 15 or 20 miles extend around the American shore of the Great Lakes." (SU)

45

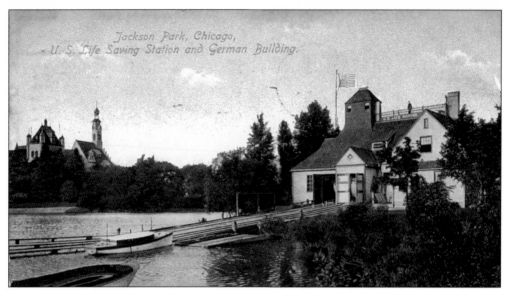

LIFE-SAVING STATION AND GERMAN BUILDING. Continuing from the *Guide to Chicago*: "Contrary to the condition of things on the Atlantic coast the busiest time here for the life savers is during the summer when the lake teems with boats both great and small. Officially navigation on the Great Lakes is closed from midnight of November 30 to midnight of March 31. During this time the life saving stations on the lakes are inhabited only by a caretaker and boats that brave the wintry seas do so at their own risk." (FP-1908)

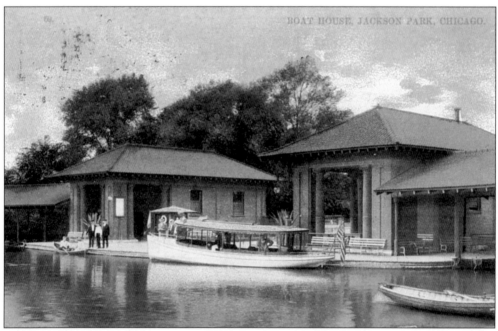

BOATHOUSE. The Jackson Park boathouse was located at the northwest corner of the lagoon. Boating was a popular activity during the summer; in the winter the lagoons were used for ice-skating.

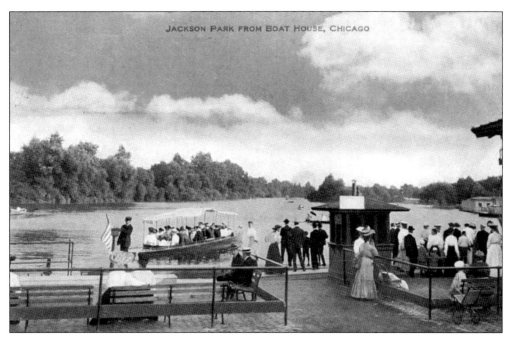

LAGOON FROM BOATHOUSE. This view of the lagoon is looking south from the Boathouse. In 1912, visitors paid 10 cents for a tour of the lagoon via electric or gasoline launches. For 20 cents, the ride would continue onto Lake Michigan. (VOH-1909)

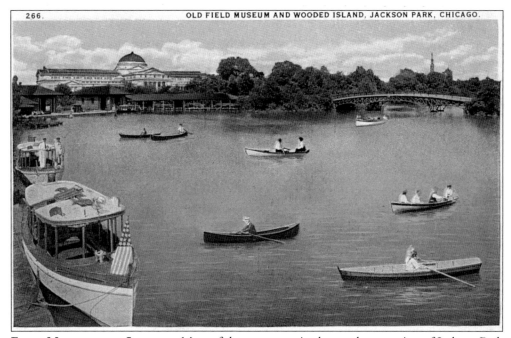

FIELD MUSEUM AND LAGOON. Most of the structures in the northern section of Jackson Park can be seen in relation to each other in this panoramic view. They are, from left to right, the Boathouse, Field Museum, North Bridge to Wooded Island, and the German Building. (MRS)

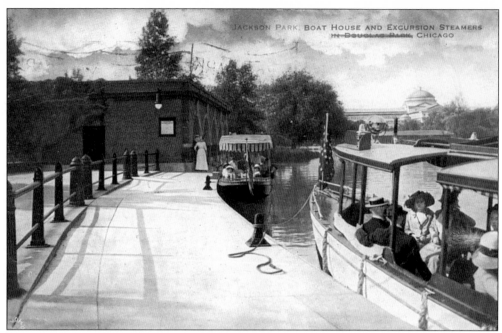

BOATHOUSE AND EXCURSION BOATS. This postcard is of the boat launch located directly southwest of the Boathouse. The photograph for the previous postcard was taken from this spot as well. (VOH-1916)

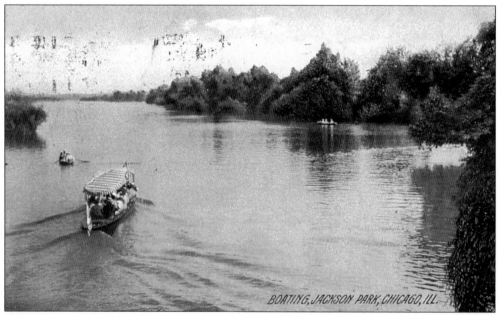

BOATING IN JACKSON PARK. In this view, the lagoon appears surprisingly vast; one can almost imagine the boat is heading down the Congo River. Also, one wonders if Walt Disney, the son of a World's Columbian Exposition construction worker, may have patterned his Jungle Cruise boats after these cheerful striped launches (or possibly the similar boats used at the World's Columbian Exposition). (R-1908)

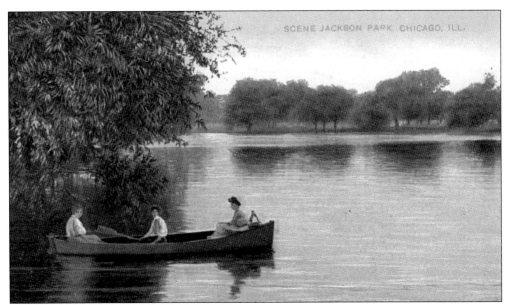

BOATING IN JACKSON PARK LAGOONS. "The beautiful lagoons of Jackson Park, in one of which is the Wooded Island, are worthy of special mention. At the boat house may be obtained comfortable row boats." (*Guide to Chicago*, 1909) (SHK)

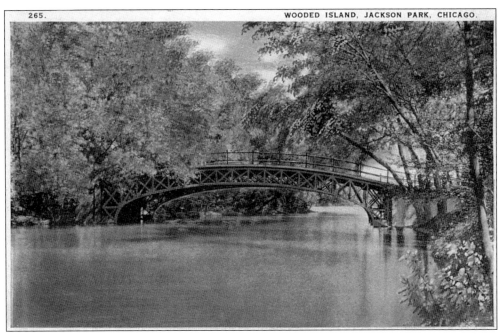

BRIDGE TO WOODED ISLAND. Wooded Island was designed for the 1893 World's Columbian Exposition by Frederick Law Olmsted. Olmsted believed that the natural quality of the island and lagoon would provide balance and relief from the surrounding exposition buildings. At the time of the World's Columbian Exposition there were four bridges leading to Wooded Island. After the Fair there were only two; a bridge at the south end of the island, depicted here, and another at the north end. (MRS.)

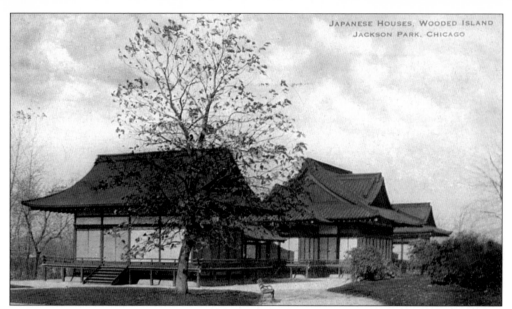

JAPANESE HOUSES FROM THE SOUTHEAST. During the planning for the World's Fair, Olmsted strongly resisted repeated attempts to place structures on the Wooded Island. He finally relented, allowing the Japanese buildings (the Ho-o-den) to be erected at the northern end of the island. The buildings and garden were financed by the government of Japan at a cost of $120,000 (about $2.4 million today) and were presented to the city of Chicago at the conclusion of the Fair. A teahouse from the Century of Progress World's Fair was added in 1934 and the buildings remained until the mid-1940s when they were lost to fires. In the years following, the gardens gradually disappeared. In the 1980s, the gardens were replanted, a new teahouse was constructed and the area was named the Osaka Garden after Chicago's sister city. (VOH-1910)

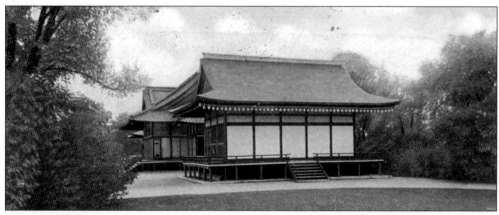

JAPANESE HOUSES FROM THE NORTHEAST. Japanese art and architecture had a profound influence on Frank Lloyd Wright, a young architect in Chicago at the time of the World's Columbian Exposition. The Ho-o-den was Wright's first direct contact with Japanese buildings, and elements which emerged later in his Prairie style may have originated from his study of these buildings. Possibly inspired by the Ho-o-den were his cruciform arrangement of living spaces, roofs with large overhangs, horizontal banding, a belief that dwellings and temples were interchangeable, and the notion of a central family hearth. (FP-1914)

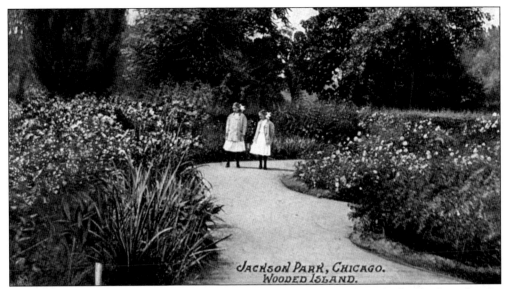

WOODED ISLAND. These two girls are enjoying the large rose garden which was planted at the southern end of Wooded Island for the World's Columbian Exposition. It remained a popular attraction for many years. "Near the south end of the Wooded Island is the old fashioned Rose Garden. In June when the roses are in their prime the garden is always thronged." (*Guide to Chicago*, 1909) (UN)

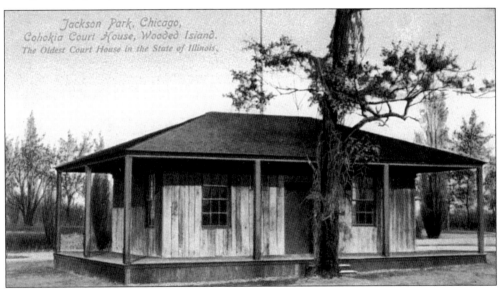

CAHOKIA COURT HOUSE ON WOODED ISLAND. "An interesting feature of the Wooded Island is the Cahokia Court House, reputed to be the oldest public building in the Mississippi Valley. It was built about the year 1716 at Cahokia, Illinois. . . . [It] was first removed from Cahokia for exhibition at the Louisiana Purchase Exposition at St. Louis in 1904, and shortly afterward was brought to Chicago and placed in Jackson Park. . . . The building is constructed of squared walnut logs set on end in the early French manner of stockade construction, the logs being held together with wooden pins" (*The Souvenir Guide to* Chicago, 1912). In 1939, the building was dismantled, returned to its original site, and restored.

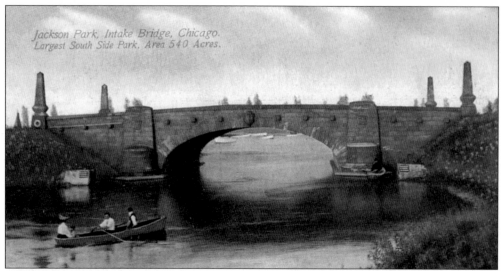

INTAKE BRIDGE. The Intake Bridge, now known as the South Bridge or Animal Bridge, was constructed in 1903. It is located at the southern end of Coast Guard Drive, and spans the waterway connecting the inner lagoon and the motorboat harbor. The project was an early use of steel-reinforced concrete in a bridge design. Limestone and granite were used as facing material, and for the carvings of hippopotamus heads and prows of boats and water deities which ornament the sides. The bridge was dismantled, cleaned, and restored in 2002–2003. (1912)

HARBOR FROM INTAKE BRIDGE. This *c.* 1920 view of the harbor is from the Intake Bridge. The caption on back reads: "Jackson Park is located on the south side extending 1 1/4 miles along Lake Michigan from 56th to 67th Streets. It has a total area of 543 acres. It contains nearly 8 miles of drives, numerous walks and bridle paths, 107 acres of artificial lakes, and 15315 square yards of out-door gymnasiums. It is the site of the World's Columbian Exposition and contains a number of its landmarks, among them the Field Museum of Natural History." (GB)

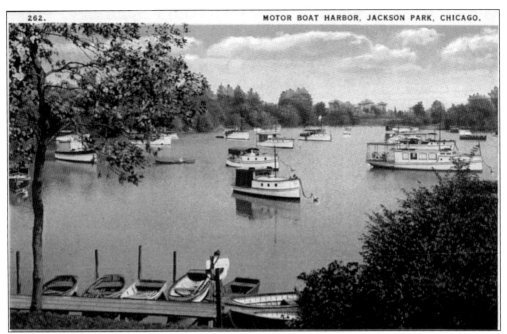

MOTOR BOAT HARBOR. This view of the yacht harbor is from the south end looking to the northeast. The 63rd Street Beach Pavilion is visible in the distance. (MRS)

DAILY NEWS SANITARIUM, JACKSON PARK, CHICAGO

LA RABIDA SANITARIUM. Built for the World's Columbian Exposition, the Convent of La Rabida was a replica of the Spanish monastery where Columbus was said to have awaited Queen Isabella's decision regarding his voyage. During the Fair it exhibited Columbus documents and artifacts. After the Fair's closing the Spanish Consulate donated the building to the city of Chicago to be used as a children's fresh air sanitarium. It was used "during three months of the summer for the care of sick babies from the congested sections of the city." In 1931, the sanitarium moved into a new building constructed nearby where it still operates today, as La Rabida Children's Hospital. (VOH)

53

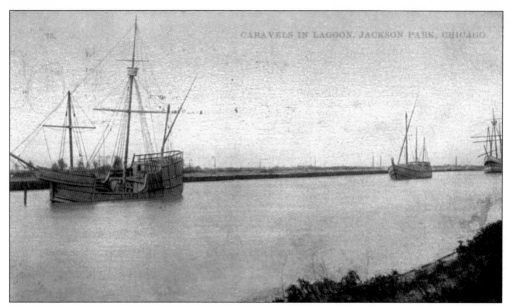

CARAVELS IN LAGOON. Replicas of Christopher Columbus' three ships, constructed in Spain, were displayed at the World's Columbian Exposition and remained in Jackson Park after the Fair closed. The landscaping suggests that this photograph was probably taken before 1901; in that year the city began to revitalize the somewhat bare post-Exposition grounds to create the modern Jackson Park. (1910)

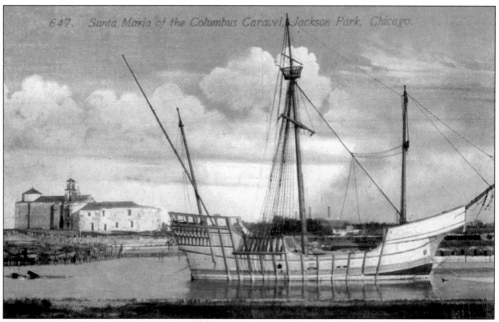

SANTA MARIA AND LA RABIDA. Another early view of the Santa Maria and La Rabida Sanitarium, viewed from the northwest. The Columbus ships were often referred to as "caravels," which is the name for a 15th- or 16th-century ship with a broad bow, high narrow poop, and three masts with lateen (or square and lateen) sails. (A)

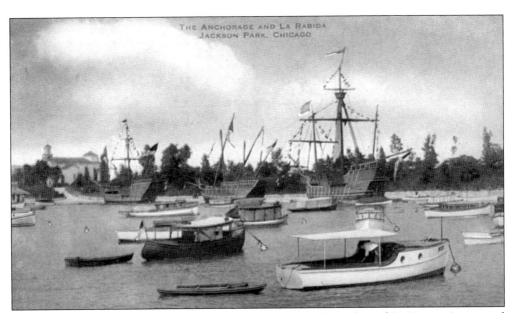

THE ANCHORAGE AND LA RABIDA. "In Jackson Park a yacht harbor of 24.26 acres is reserved for the anchorage of private pleasure boats, both sail and power. Moorings are furnished without charge by the park commissioners for 150 boats. All moorings are occupied during the season, and there is usually a large waiting list. An interesting reminder of Columbus are three small caravels . . . on exhibition in the south lagoon, not far from the convent." (*The Souvenir Guide*, 1912) (VOH-1915)

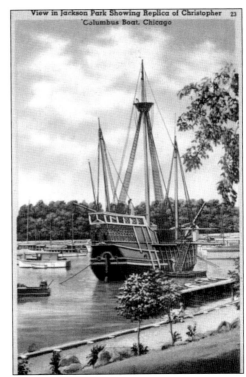

View in Jackson Park Showing Replica of Christopher 23
Columbus Boat. Chicago

SANTA MARIA IN THE JACKSON PARK HARBOR. Of the three Columbus ships, the Santa Maria survived the longest. The Pinta sank in 1918, the Niña succumbed to fire in 1919, and the Santa Maria, after falling into a state of disrepair, was removed from the park sometime between 1948 and 1958. (CLC)

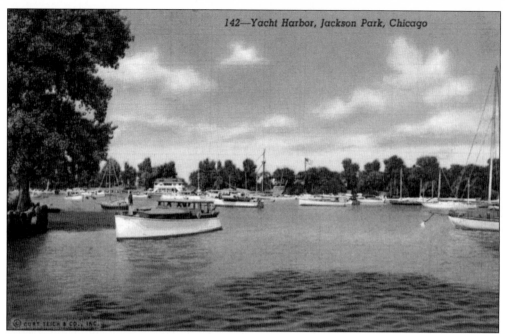

YACHT HARBOR. A slightly later view of the yacht harbor, the viewpoint of this card is looking northeast toward the new La Rabida Hospital, barely visible beneath the flag in the center. Also in the distance are the Jackson Park Yacht Club (the building to the left) and, directly in the center, the remaining Columbus ship, the Santa Maria. (CT-**1941**)

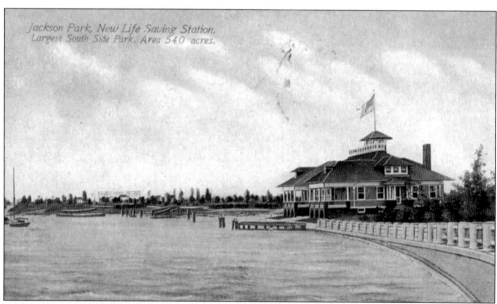

NEW LIFE-SAVING STATION. This life-saving station was built in 1906. It replaced the station just north of it that had been built for the World's Fair and afterwards had served as a U.S. Life Saving Station (see p. 45). Located on Coast Guard Drive, this building now houses a restaurant. (FP-**1919**)

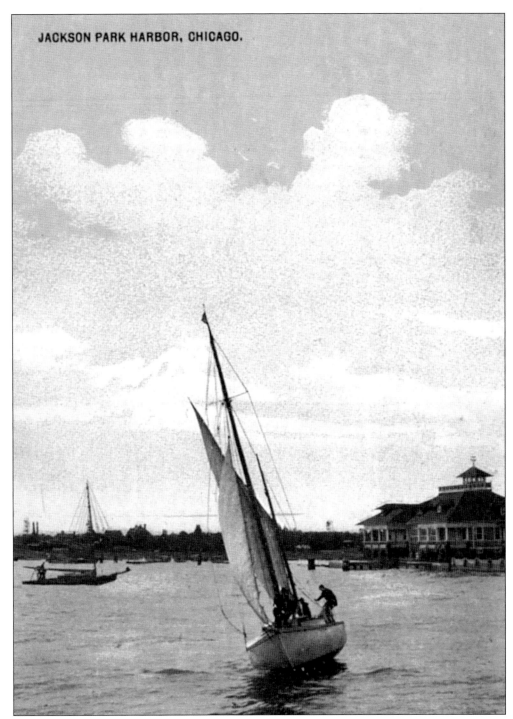

JACKSON PARK HARBOR, CHICAGO.

HARBOR AND NEW LIFE-SAVING STATION. The sailboat in this view was about to leave the harbor and enter the waters of Lake Michigan. It had just passed the new life-saving station (to the right), and at this moment would have been drawing alongside La Rabida Sanitarium (compare to view on p. 53). (1914)

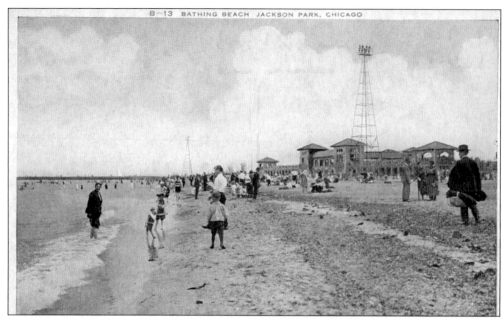

BATHING BEACH AT JACKSON PARK. The Bath House and enormous light towers are visible to the right in this view, looking south at the 63rd Street Beach. (VOH)

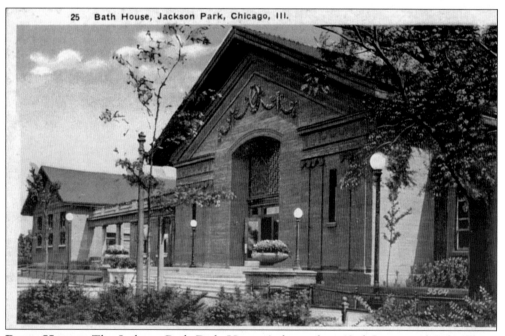

BATH HOUSE. The Jackson Park Bath House is located at 63rd Street and Lake Shore Drive and, like many South Park buildings, was designed by the firm of Burnham and Company and constructed of concrete. Built in 1919, the bath house provided lockers, showers, and an infirmary. A covered promenade was attached. The building operates today in much the same capacity. (GB)

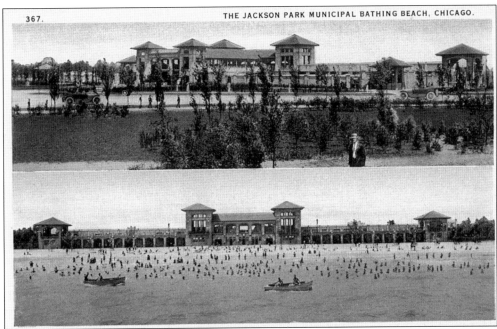

367.

JACKSON PARK BEACH AND BATH HOUSE. In this view, the Bath House and 63rd Street Beach are viewed from the southwest (above) and east (below). In the lower view, patrolling lifeguards keep watch from rowboats just beyond the swimmers; a practice still followed by lifeguards at Chicago's municipal beaches. (MRS)

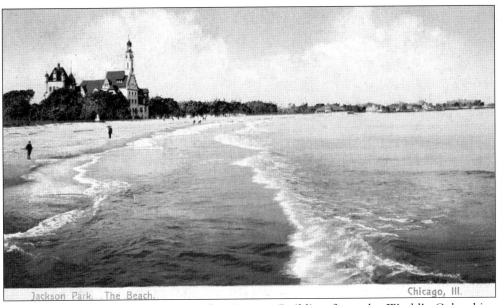

Jackson Park, The Beach. Chicago, Ill.

GERMAN BUILDING AND BEACH. The German Building from the World's Columbian Exposition is visible in this early-1900s view of 57th Street Beach, looking northward. In the distance is the Pavilion (or Iowa Building), and further right and just barely visible, the Chicago Beach Hotel. (WN)

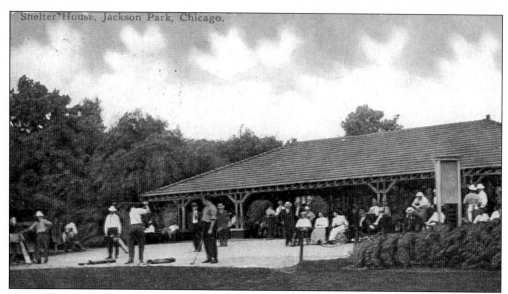

GOLF SHELTER HOUSE. The Jackson Park golf course opened in 1899, and was the first public course west of the Allegheny Mountains. *The Souvenir Guide* (1912) described the Park's golf facilities this way: "There are two golf courses maintained in Jackson Park, one 9-hole and the other 18-hole. At the first tee of the 18-hole course there is a large shelter, with commodious lunch counter, 750 lockers, and shower baths for both men and women. All these are furnished free of charge, and the demand is so great that, notwithstanding the fact that four persons are assigned to each locker, all who apply for space cannot be accommodated. The use of the course is very great, as many as 1,400 people playing over the 18-hole course in one day." (1912)

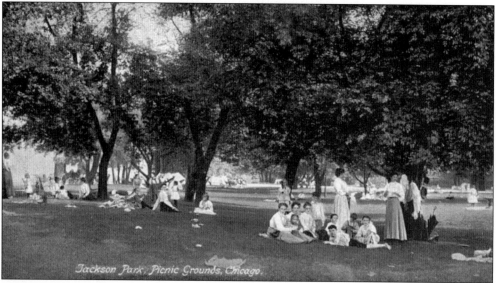

PICNIC GROUNDS. The park commissioners attempted to maintain a wholesome and inviting environment for women and children at the South Parks by limiting the sale of alcohol at park refectories. This photograph of female picnickers in Jackson Park suggests that their efforts were successful—although, with nary a male in sight, perhaps at the cost of driving men away! (NS-1908)

60

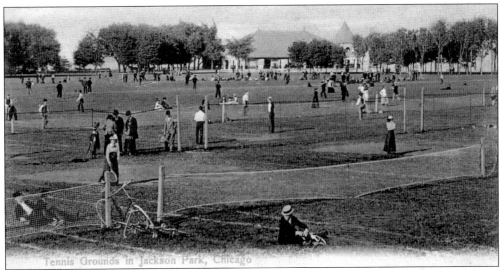

Tennis Grounds in Jackson Park, Chicago

TENNIS GROUNDS. These tennis courts were on the lawn on the north side of the Field Columbian Museum (now the Museum of Science and Industry). The Pavilion and Lake Michigan beyond are visible in the background. "The 40 tennis courts maintained by the Park Commissioners in various parts of the park are for the use of the public without charge, the players being changed every even hour provided there are persons waiting. Many courts are marked out for the use of those who bring their own nets, and when they place their net upon a court it is theirs for the day, provided they wish to continue its use." (*Souvenir Guide*, 1912) (KK)

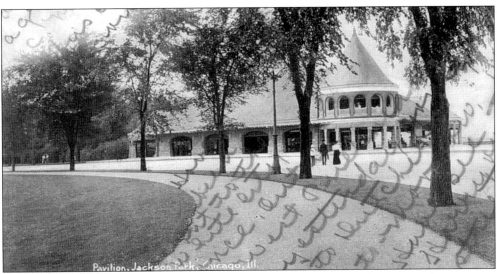

Pavilion, Jackson Park, Chicago, Ill.

THE PAVILION. The Pavilion was an open park shelter built in 1888 in the northeast section of Jackson Park. It was enlarged and modified for use as the Iowa State Building during the World's Columbian Exposition. After the Fair, the Pavilion was returned to use as a park shelter but was now also called the Iowa Building. In 1936, when South Lake Shore Drive was constructed, the building stood in its way and had to be demolished. The WPA erected a replacement shelter nearby at 57th and Lake Shore Drive, also called the Iowa Building, which still stands. The author writes: "We are having a great time. . . . Have been out to the White City once. Out to West Pullman yesterday." (R-1907)

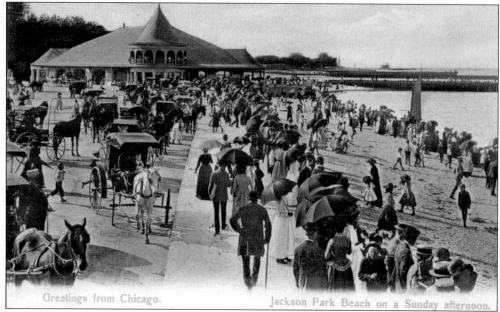

Greetings from Chicago. Jackson Park Beach on a Sunday afternoon.

JACKSON PARK BEACH AND PAVILION. This photograph seems to pre-date the automobile, as none are visible in this view. Although some of the figures appear to be added, the photograph doesn't seem to be as doctored as the view below. It's interesting to note that no one is dressed for bathing in the lake. If the title is accurate and this indeed depicts a Sunday afternoon, this postcard suggests that Sunday visits to the park during this period tended to be of a formal, promenading nature. (KK-1906)

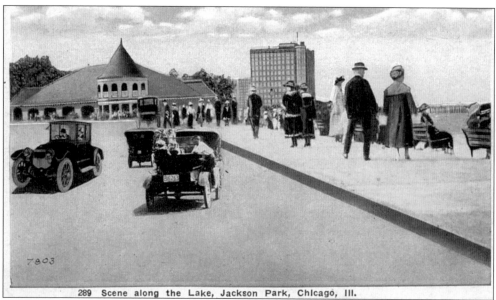

289 Scene along the Lake, Jackson Park, Chicago, Ill.

PAVILION AT JACKSON PARK. A similar but slightly later view, this amusing card has been liberally "enhanced." Figures, automobiles, and buildings have been added with little regard to accuracy or the rules of perspective, and the resulting image is more a collage than photograph. (GB)

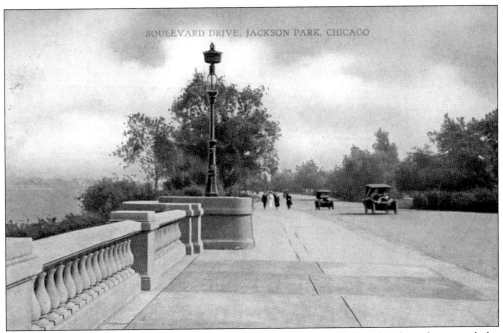

BOULEVARD DRIVE AT JACKSON PARK. This bridge on the lakeside boulevard spanned the North Haven inlet near the old Life-Saving Station, southeast of the Field Columbian Museum. It remains there today, on South Lake Shore Drive, just south of the lawn bowling green. (VOH)

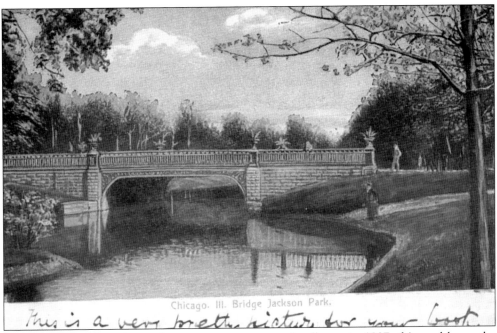

Chicago. Ill. Bridge Jackson Park.

BRIDGE IN JACKSON PARK. Sent to a young postcard collector in 1907, this card bears the following message: "This is a very pretty picture for your book." (PS-1907)

The MUSEUM of SCIENCE and INDUSTRY

• FOUNDED BY JULIUS ROSENWALD •

A PRESENTATION of scientific and engineering achievements where visitors can push buttons and pull levers to their hearts' content and see and hear the answer to the eternal question of the machine age, "How and why does it work?". It is a museum of the new age—an age in which things move.

(Over)

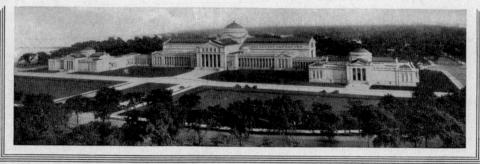

MUSEUM OF SCIENCE AND INDUSTRY PROMOTIONAL CARD. This *c.* 1933 card announced the partial opening of the Museum of Science and Industry. The scope of the museum, future exhibits, and plans to obtain exhibits at the conclusion of the 1933–34 Century of Progress Fair are explained on the reverse (at right). Today's still-popular coal mine exhibit was among the first opened, and its 25 cent admission was the only fee charged at the museum. The projected completion date for the museum's reconstruction was given on this card as 1935 but, in fact, the museum was not finished until 1940.

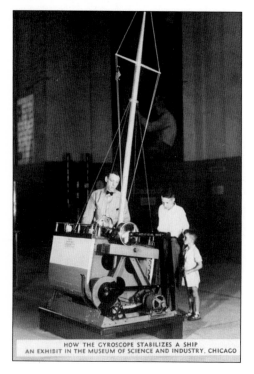

HOW THE GYROSCOPE STABILIZES A SHIP
AN EXHIBIT IN THE MUSEUM OF SCIENCE AND INDUSTRY, CHICAGO

GYROSCOPE EXHIBIT. The Museum of Science and Industry was founded by Julius Rosenwald. Rosenwald, president of Sears, Roebuck, and Company, made an initial contribution of 3 million dollars which enabled the crumbling exterior walls of the former Palace of Fine Arts/Field Museum to be replaced with marble and limestone, identically matching their original appearance. The interior was remodeled in the Art Moderne style of the time, and the hands-on exhibits like this gyroscope model were patterned after those found in science museums of Europe, especially Munich's Deutches Museum. (DPS)

An Institution to Reveal
——— THE ———
Technical Ascent of Man

THE MUSEUM OF SCIENCE AND INDUSTRY is situated on Lake Michigan at 57th street. Its collections will trace the technical progress of man from primitive times to the present day. Eleven miles of exhibits will tell in three dimensional form the story of man's use of tools and machines from the stone hatchet to the complicated machines of today.

The vast interior of this building, designed to accommodate the planned exhibits, will not be completed until 1935. However, a large area unfinished as to tile and plaster, but impressive as to sturdiness and space, has been prepared to welcome the visitor during 1933 and to present the initial exhibits where entertainment, education and inspiration provide a new avenue of recreation and study.

The section now open to the public contains enough exhibits to give the visitor a cross-sectioned view of what the finished museum will be like. Chief among these exhibits is a full-sized operating bituminous coal mine of three thousand tons a day capacity. In addition to the coal mine with its underground workings and huge operating machines, there are many other exhibits relating to the geology, production, economics and utilization of coal.

At the conclusion of A Century of Progress many of the important World's Fair exhibits will be placed in the museum and at that time the other sequences will be opened. These will consist of exhibits on the Fundamental Sciences of Physics and Chemistry and on Geology, Mining, Agriculture, Forestry, Power, Transportation, Architecture and City Development and Printing and the Graphic Arts.

REVERSE OF PROMOTIONAL CARD AT LEFT.

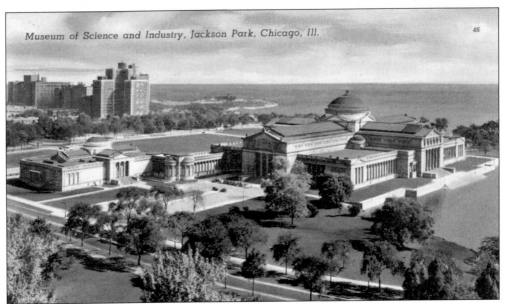

Museum of Science and Industry, Jackson Park, Chicago, Ill.

MUSEUM OF SCIENCE AND INDUSTRY VIEWED FROM THE SOUTHWEST. In this view, Promontory Point, created in the late 1920s, can be seen jutting into Lake Michigan in the center background. The high-rise to its left is Jackson Towers, leading a row of lakefront hotels. (CP)

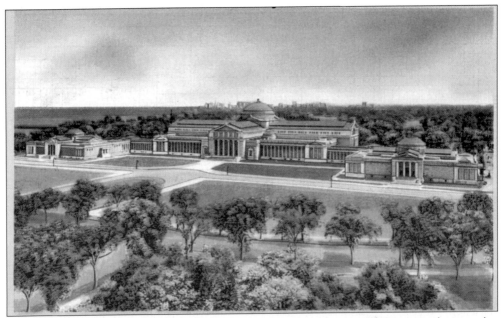

MUSEUM OF SCIENCE AND INDUSTRY VIEWED FROM THE NORTH. The museum's expansive parking lot dominated this view for many years. In 1998, however, an underground parking garage was completed. Grass was planted where the parking lot had been and the building was returned to its original park-like setting, as illustrated in this 1930s-era view. A great attraction for the city of Chicago, the Museum of Science and Industry is visited by 2 million people annually. The building was designated a Chicago Landmark in 1995. (CLC)

Three
THE UNIVERSITY

"This great seat of learning, facing the broad expanse of Midway Plaisance, eight miles from the center of Chicago, is a wonderful institution of world-wide reputation. Its marvelous growth in wealth, influence, and number of students is characteristic of Chicago as a whole, and still more to be wondered at when it is considered that the first students were admitted to very inadequate and incomplete quarters and facilities no longer than sixteen years ago." (*Guide to Chicago*, 1909)

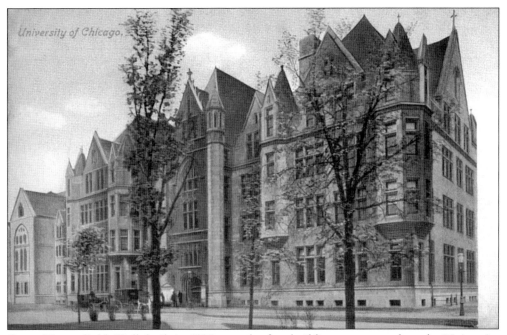

COBB HALL. Cobb Hall, built in 1892, was the first building constructed on the University of Chicago campus. It was designed by Henry Ives Cobb and contained almost all of the activities of the University when it first opened, including administration, teaching, and religious services. It was named, not after the architect, but in honor of its benefactor, Silas B. Cobb. (FP-1910)

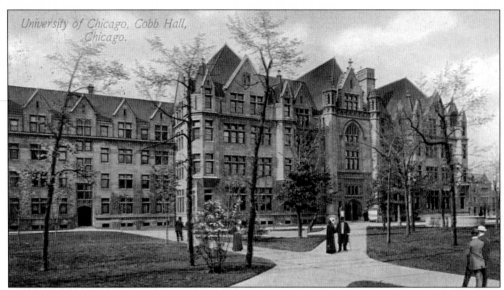

COBB HALL AND DIVINITY DORMITORIES. Adjacent to Cobb Hall and also designed by Henry Ives Cobb and built in 1892, were the men's dormitories: Graduate, Middle, and South Divinity Halls. Originally housing 50 students each, they are now used for offices and classrooms, and have been renamed Blake, Gates, and Goodspeed Halls. Goodspeed Hall is used by the Department of Music. (FP-1910)

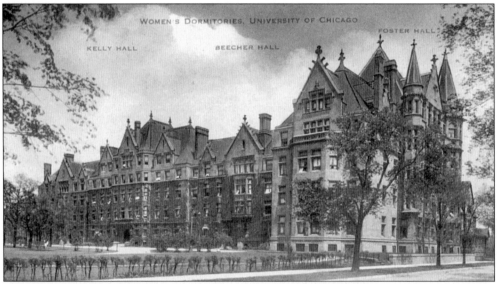

WOMEN'S DORMITORIES. The first women's dormitories, Foster, Kelly, and Beecher Halls, were built in 1893 across the Quadrangle from the men's dormitories. They mirrored the men's dormitories in arrangement and height. Space was reserved between Beecher and Kelly Halls for a fourth dormitory, Green Hall, which was added in 1899. In large part due to the suggestions of Dean of Women Marion Talbot, the women's dormitories were designed somewhat differently from the men's; the women had single rather than double rooms and more parlors and public areas for socializing. This view from the southwest is now blocked by Harper Library and the Social Sciences Research Building. (VOH-1914)

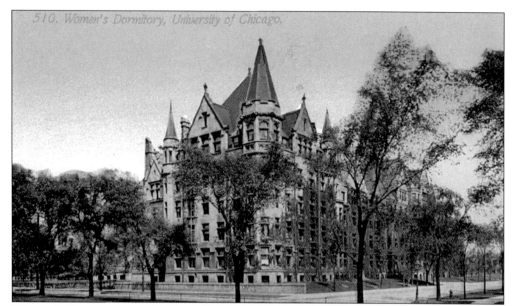

WOMEN'S DORMITORIES. Taking advantage of Foster Hall's prominent location overlooking the Midway Plaisance, architect Henry Ives Cobb called attention to its southeast corner with an ornamented oversized turret. Foster Hall can be seen in many photographs taken during the World's Columbian Exposition, incongruously rising up behind Midway Plaisance attractions such as the Ostrich Farm and Streets of Cairo.

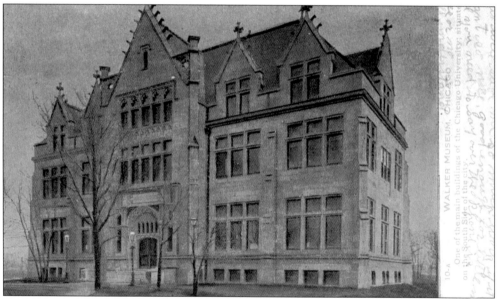

WALKER MUSEUM. The Walker Museum as built in 1893. It was designed by Henry Ives Cobb as a natural history museum with large exhibition spaces for the display of prehistoric skeletons. The needs of the departments of geology, anthropology, geography, and paleontology, however, necessitated conversion of much of its space into classrooms, offices, and laboratories. The University's paleontology collections were transferred to the Field Museum in the late 1940s and early 1950s. (NYP-1909)

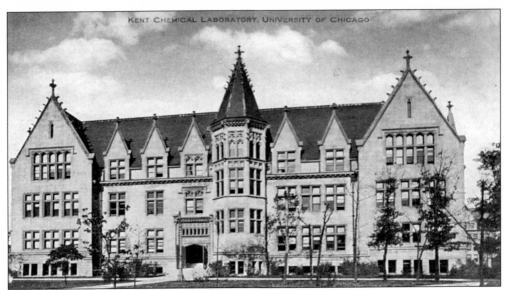

KENT CHEMICAL LABORATORY. While the southern quadrangles were developed for residential use, the northern section of the campus was planned for the science laboratories. Kent Laboratory and its neighbor to the east, Ryerson Laboratory, were the physical science laboratories, and were the first to be built. Both were designed by Cobb, and because of their expensive interior requirements and highly ornamented exteriors, both went severely over budget. (VOH)

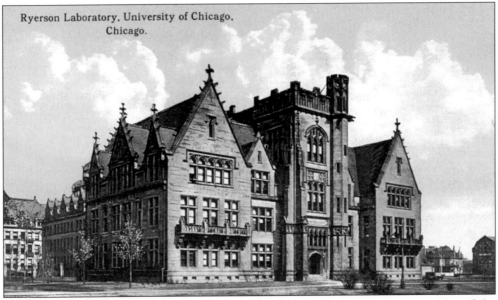

Ryerson Laboratory, University of Chicago, Chicago.

RYERSON PHYSICAL LABORATORY. Ryerson and Kent Halls provide fine examples of the Gothic ornamentation employed by Cobb in his designs for the University of Chicago. Along their gabled rooflines are gargoyles and evenly spaced spiky plant-inspired ornaments called "crockets." The ornamentation on Ryerson also included balconies and parapets. After Ryerson Physical Laboratory was built, University President William Harper declared it to be "the most beautiful university building in the world." (EA)

HASKELL ORIENTAL MUSEUM. Haskell Oriental Museum (Henry Ives Cobb, 1896) was built to house the University's collection of ancient Near East artifacts. Skylights in the roof originally illuminated the galleries. The Department of Semitic Languages was also housed in the building, and the Chair of the Department (and University President), William Rainey Harper, maintained offices there until his death in 1906. To the right of the entrance is a cornerstone with inscriptions in Hebrew, Latin, and Greek which translate, "Light from the East." The collection moved to its present location, in the newly built Oriental Institute, in 1932. (MRS-1917)

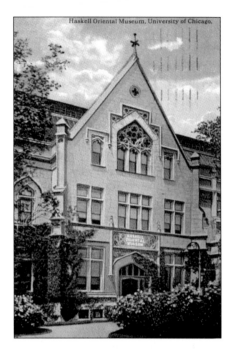

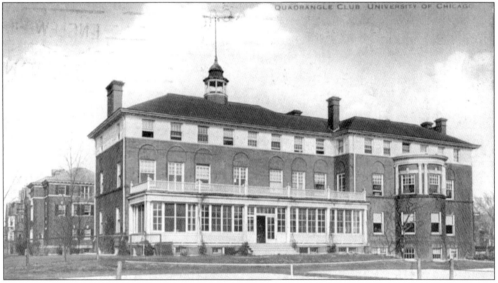

QUADRANGLE CLUB. The Quadrangle Club, built in 1896, was the only 1890s-era University building not designed by Henry Ives Cobb. The architect was Charles B. Atwood, who was also architect of the nearby Palace of Fine Arts in Jackson Park. The Quadrangle Club itself was founded in 1893, to serve as a faculty club for the University of Chicago and gentlemen's club for members of the community. In 1929, this building, originally located on the site of the present Oriental Institute, was cut into two pieces and moved west to its present location at 960 East 58th Street. The entrance is now on the rear (south) façade, which is depicted on this postcard. The building is now known as Ingleside Hall. Note: The house visible in the background, where the Chicago Theological Seminary is today, was moved in the 1920s to 5727 South University Avenue, where it was rotated 90 degrees and still remains. (VOH)

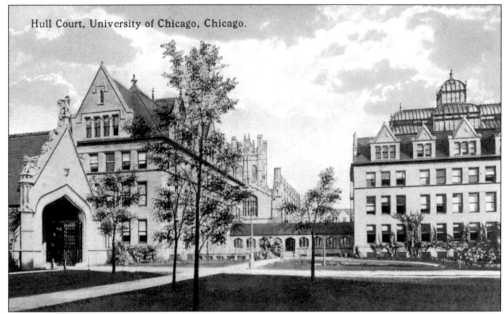

Hull Court, University of Chicago, Chicago.

HULL COURT. Hull Court is a courtyard enclosed by the four buildings which make up the Hull Laboratories: Physiology (now called Culver), Anatomy, Zoology, and Botany (now Erman). The four buildings, designed as one unit with connecting loggias, were constructed in 1897. The courtyard is enclosed by an ornate iron fence and gate to the south and the magnificent Cobb Gate to the north. The landscaping was designed by Olmsted and Olmsted, son and stepson of the famed landscape architect Frederick Law Olmsted, in 1902. (MRS)

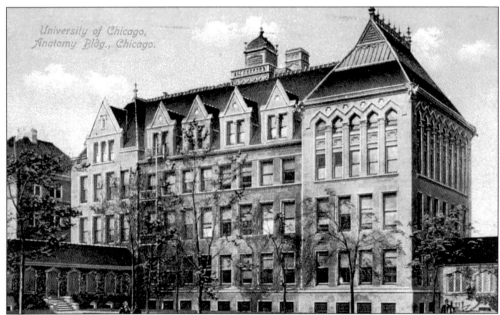

University of Chicago, Anatomy Bldg., Chicago.

ANATOMY BUILDING FROM HULL COURT. The Anatomy Building is still used by the Department of Organismal Biology and Anatomy. (1910)

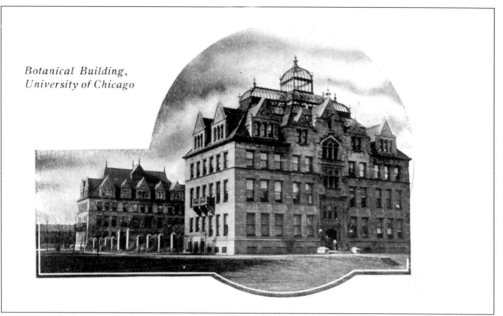

Botanical Building, University of Chicago

BOTANY BUILDING. This early view looking northwest clearly shows the greenhouse which was atop the Botany Building roof until its removal sometime after 1964. The Physiology Building is visible to the left. Here, the landscaping appears strikingly bare.

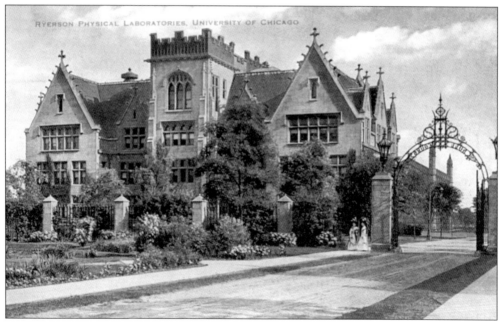

RYERSON FROM HULL COURT. This view of Ryerson, from the north, includes Botany Pond and Hull Court in the foreground. Botany Pond and Hull Court enjoyed a variety of exotic plants set outside by the Botany Department during the summer months. Note the iron fence, gate, and ornate lanterns to the right in this view. (VOH-1915)

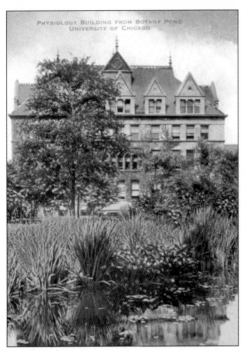

PHYSIOLOGY BUILDING FROM BOTANY POND. Botany Pond was designed by John Olmsted, stepson of Frederick Law Olmsted, with the assistance of the Botany Department's first chair, John M. Coulter. Coulter, whose private plant collection was unparalleled at the time, used the area as an outdoor laboratory and garden. Remnants of the lushly planted landscape he created may still remain; an usual variety of aralia growing along the iron fence probably descends from Coulter's plantings. (VOH-1910)

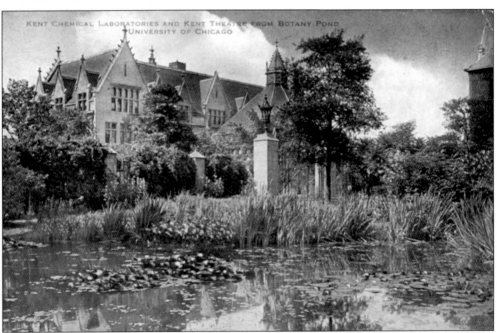

KENT FROM BOTANY POND. On the north side of Kent Chemical Laboratory is the octagonal Kent Theater, visible in the center of this view. It seated 560 and until the construction of Mandel Hall in 1903, it also served as the University's assembly hall. This pond view seems especially fitting for the message written on the back, which begins: "Be jabbers there's another mosquito. They're so crazy about me that there's not much left of me. . . ." (VOH-1914)

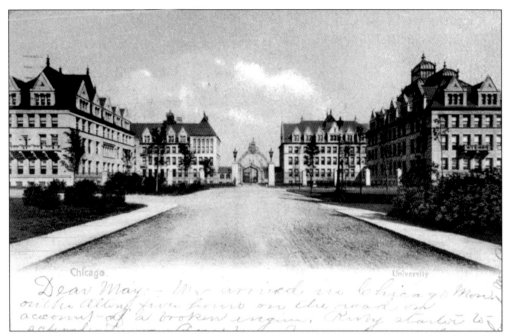

Chicago University

Dear May:— My arrived in Chicago Mon on the Allny five hours on the road on account of a broken engine. Ruby starlei b

HULL COURT AND LABORATORIES. This view, looking north, depicts the Biological Laboratories Quadrangle comprising, from left to right, Physiology, Anatomy, the wrought-iron Hull Court gate and Cobb Gate beyond, Zoology, and Botany Buildings. Note the young trees in the foreground. (CT-1904)

HULL GATE. Now known as Cobb Gate, this portal connects the loggias of the Anatomy and Zoology Buildings and provides entrance from 57th Street to the Hull Biological Laboratories, Hull Court, and main quadrangle beyond. The gate is ornamented with gargoyles and griffins, which are said to represent the admissions counselors, blocking the base on either side, and, struggling upward, the first, second, and third-year students. Triumphantly seated atop the peak is the fourth-year student. Cobb Gate, built in 1900, was donated to the University by its architect Henry Ives Cobb, and was his final design for the University of Chicago. (UC)

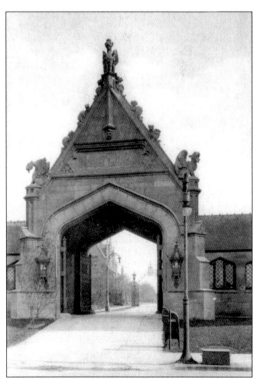

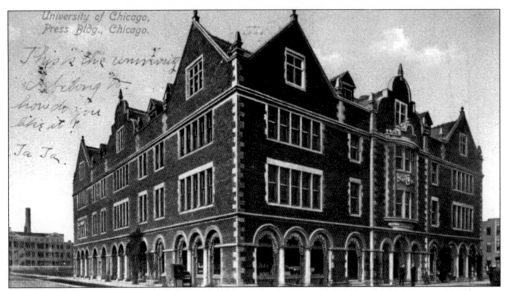

UNIVERSITY OF CHICAGO PRESS BUILDING. Constructed in 1902, this red-brick and limestone building was designed by Shepley, Rutan and Coolidge. In its early years, it housed not only the University of Chicago Press but, until Harper Memorial Library was completed in 1912, the University's library. Since 1971 the building has been occupied by the University Bookstore. This view from the southeast also shows, to the left, the headquarters for the American School of Correspondence. It was built in 1906–07, designed by architects Pond and Pond, and has been designated a Chicago Landmark. (1910)

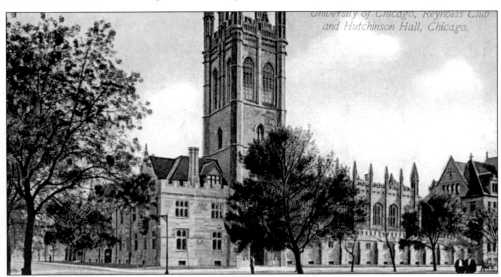

REYNOLDS CLUB, MITCHELL TOWER, AND HUTCHINSON HALL. This complex, built in 1903, was designed by the architectural firm of Shepley, Rutan and Coolidge, which replaced Henry Ives Cobb as architects for the University. It marked a shift from Cobb's free and personal interpretation of the collegiate Gothic style to a greater emphasis on historicism (both exterior and interior). Two of these buildings are, in fact, almost identical copies of examples found at Oxford University. Mitchell Tower is patterned after the tower of Magdalen College, and Hutchinson Hall after Christ Church Hall. (FP)

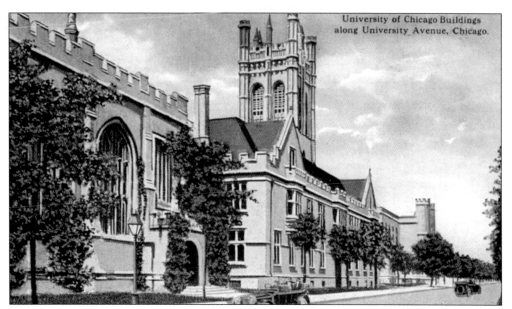

REYNOLDS CLUB FROM THE SOUTHEAST. This view, shows the north end of Mandel Hall, at the left, and the Reynolds Club and Mitchell Tower in the center. Within Mitchell Tower, the University's first purely ornamental building, is a set of ten bells. The bells are used to carry on an old English tradition known as change ringing, which is a continuous (and somewhat cacophonous) ringing of the bells in every possible order. (MRS-1917)

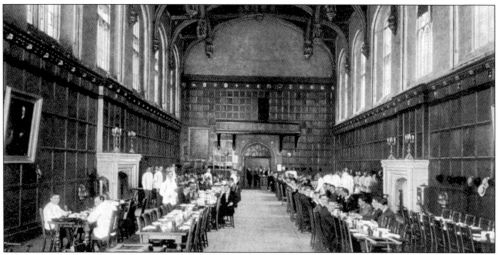

HUTCHINSON COMMONS. Hutchinson Hall was built to provide a dining hall for male students who, until then, had to leave the campus for meals. Like the exterior, the interior of the dining hall was patterned after Christ Church Hall, even to the point of imitating the portraits hung on the wall. Oxford's paintings, however, depict royal patrons; Chicago's are of presidents, trustees, and benefactors. The two portraits shown in this postcard still hang in Hutchinson Commons but, through the years, have been joined by many others. The hall remains in use as a cafeteria and, aside from the number of portraits and table arrangement, looks much the same today. (VOH)

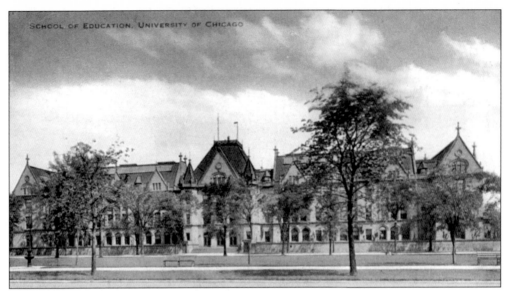

SCHOOL OF EDUCATION. Facing the Midway Plaisance, the School of Education buildings housed the University Laboratory Schools. Founded in 1895 by the educator John Dewey, the school served as a laboratory to test and practice his theories of education for elementary and high school-aged students. The building pictured, Emmons Blaine Hall (James Gamble Rogers, 1903), is now used by the Lower School of the University of Chicago Laboratory Schools, which includes kindergarten through fourth grade. (VOH)

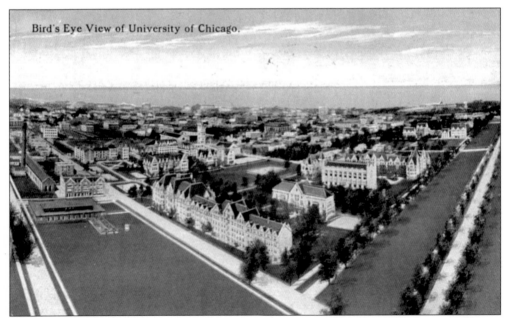

BIRD'S EYE VIEW LOOKING NORTHEAST FROM THE MIDWAY PLAISANCE AND DREXEL AVENUE. This view of the campus can be dated from between 1904 and 1912 due to the presence of the Law School and the absence of Harper Memorial Library. The smokestack and long low building on the far left were the University's Heat, Light and Power Plant. (MRS-1914)

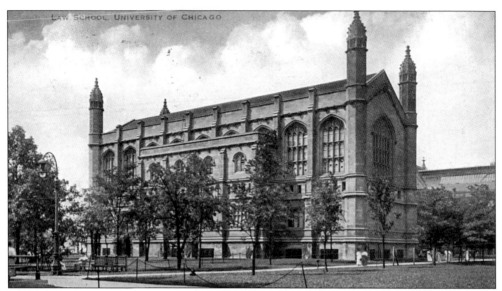

LAW SCHOOL FROM THE EAST. The University of Chicago Law School was founded in 1902. From the beginning, and years before most other law schools did so, women students were admitted. This building, by Shepley, Rutan and Coolidge, was loosely patterned after King's College Chapel at Cambridge, and was built for the Law School in 1904. Its ornamentation includes carvings of kings, magistrates, scales of justice, and, centered on the north gable, Moses and the Ten Commandments. In 1959, the Law School moved across the Midway to the Laird Bell Law Quadrangle. The Law School building is now known as Harold Leonard Stuart Hall. (VOH-1910)

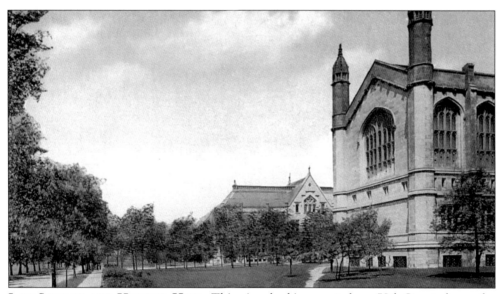

LAW SCHOOL AND HASKELL HALL. This view looking west along 59th Street shows the appearance of the main south quadrangles prior to the construction of Harper Library and the Social Science Research Building. The addition of Harper Library and Social Sciences enclosed the quadrangles and closed them off from 59th Street and the Midway Plaisance (to the left in this view). (1912)

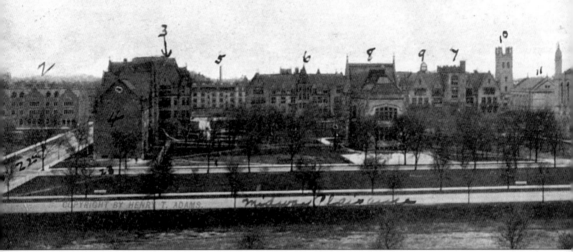

PANORAMIC VIEW LOOKING NORTH FROM THE MIDWAY PLAISANCE. This early postcard was carefully annotated by its sender, who provided the following information on the reverse side: "1. Power Plant; 2. Press and Gen. Library; 3. Cobb Hall; 4. Men's Dormitories (Grad Hall, Middle Divinity, South Divinity); 5. Hitchcock Hall. Men's Dorm.; 6. Kent Chemical Lab.; 7. Ryerson Physical Lab.; 8. Haskell; 9. Roof garden on Botany Bldg. north of Ryerson; 10. Mitchell Tower; 11. Mandel Assembly Hall; 12. Law Building; 13. Corner of Walker Museum (Geology); Women's Dorms 14. Beecher; 15. Green; 16. Kelly; 17. Foster; 18.

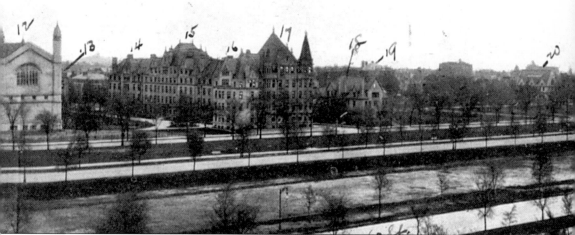

President's House; 19. Hyde Park High School where I graduated; 20. Manual Training; 21. This group includes Sch. of Education, University High School; 22. Ellis Ave.; 23. 59th St. Just west of 10 is the Commons (Hutchinson Hall). Just north of 10 is Bartlett Gym. East of 10 Reynolds Club House. The Midway is one of World's Fair fame. Directly back of 3 is Snell Hall (a Men's Dorm) and back of 6 and 7 are 4 buildings, Anatomy, Physiology, Zoology and Botany see 9." (HA-1905)

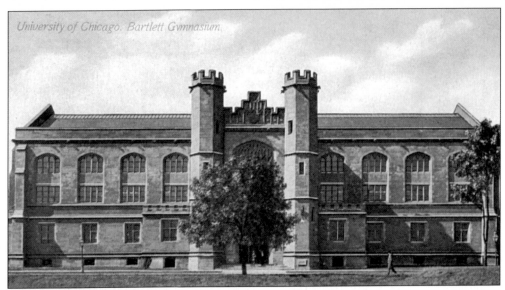

BARTLETT GYM. Built in memory of his son Frank Dickinson Bartlett, who died at the age of 20, University Trustee Adolphus C. Bartlett funded the construction of this gymnasium in 1904. Designed by Shepley, Rutan and Coolidge, its beautiful interior decoration depicts a combination of medieval and athletic scenes, including a romantic mural painted by another of Bartlett's sons, Frederic Clay Bartlett, and stained glass windows of a scene from Ivanhoe. In 2002, the building was renovated and adapted for use as a dining hall for the newly constructed dormitories beside it. This view is of the east façade, which faces University Avenue. (Note: Frederic Clay Bartlett also collected art and donated significant pieces to the Art Institute of Chicago, including George Seurat's *A Sunday on La Grande Jatte—1884*.) (FP)

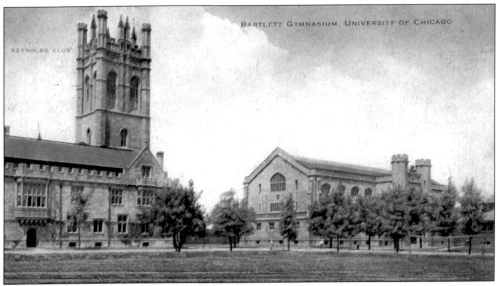

REYNOLDS CLUB, MITCHELL TOWER, AND BARTLETT GYM FROM THE SOUTHEAST. The grassy area in the foreground is the site of the present Quadrangle Club (built in 1922). Tennis nets can be seen in the foreground. Tennis is still played here, on courts behind the Quadrangle Club. (VOH-1912)

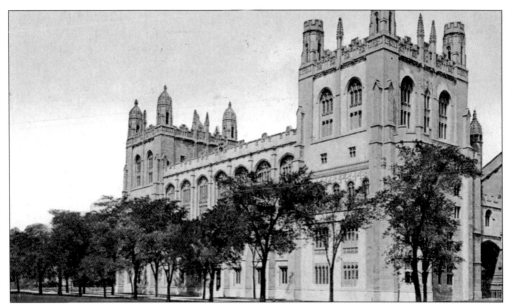

HARPER MEMORIAL BUILDING. Harper Library (Shepley, Rutan and Coolidge, 1912) was newly constructed when this card was mailed in 1913. Built in memory of the University's first president, William Rainey Harper, it cost $800,000 to construct and was financed by contributions from friends, alumni, and faculty. Its construction suffered a major setback when the nearly completed west tower collapsed in March 1911. One photograph of the wreckage, however, was light-heartedly captioned (for a student newspaper?): "Spring Vacation a' la tradition." (FP-1913)

WEST STANDS OF STAGG FIELD. Appearing a more suitable setting for medieval jousting than college football, this impressive grandstand of reinforced concrete was erected in 1913. It stood on the west side of Stagg Field (now the site of Regenstein Library) along Ellis Avenue between 56th and 57th Streets. Until 1939, when it decided to withdraw from major intercollegiate football, the University of Chicago was a football powerhouse. The football team was known as "The Monsters of the Midway" and the very first Heisman Trophy was awarded in 1935 to a Chicago player, halfback Jay Berwanger. In 1942, another sort of power was demonstrated here. On December 2nd, in a squash court beneath these stands, Enrico Fermi and colleagues created the first controlled self-sustaining nuclear chain reaction. A Henry Moore sculpture on the site memorializes the event. The stands were demolished in 1957. (UC)

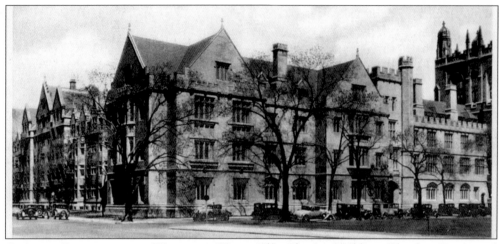

CLASSICS BUILDING AND WIEBOLDT HALL. The Classics Building (Shepley, Rutan and Coolidge, 1915) is located at the southwest corner of the campus quadrangles. The exterior ornamentation was chosen to reflect the field of study conducted within, and includes carvings of Homer, Plato, Socrates, and Cicero. In this view, looking northeast from Ellis Avenue and the Midway, Wieboldt Hall (Coolidge and Hodgdon, 1928) can be seen to the right. With the construction of Wieboldt Hall, the last remaining gap was filled in the wall of buildings which enclosed the southwest quadrangle. Originally used for the departments of modern languages, the exterior depicts authors including Goethe, Schiller, Ibsen, Shakespeare, Emerson, and Hugo. An exterior passageway located between Wieboldt Hall and the Classics Building allows access to the Midway Plaisance from the quadrangles; a stone from the original University of Chicago is embedded in the west wall of the hallway. (ECK)

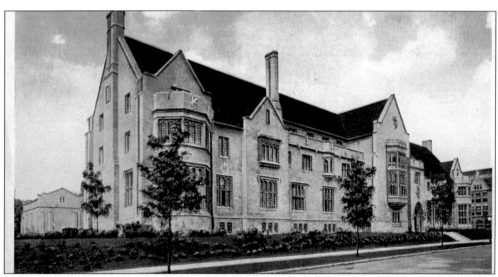

IDA NOYES HALL. Ida Noyes Hall was designed to be the women's counterpart to the Reynold's Club and Tower Group, and provided female students with lounge space, a library, the Cloister Club, and other recreational facilities. It was built in 1916 and was designed by Shepley, Rutan and Coolidge in the Tudor Revival style. The interior is richly ornamented. (Note: With the construction of Ida Noyes Hall, the Robie House's view south to the open space of the Midway Plaisance was blocked, and its visual connection to the "prairie" was lost.) (MRS)

Go Chicago! Amos Alonzo Stagg, who coached and taught at the University of Chicago from 1892 to 1932, is said to have created this famous football yell: "Chi-ca-go, Chi-ca-go, Chi-ca-go—Go! Go Chi-ca, Go Chi-ca, Go Chi-ca Go!" This postcard is from a University Women's series printed in 1905. (UL-**1905**)

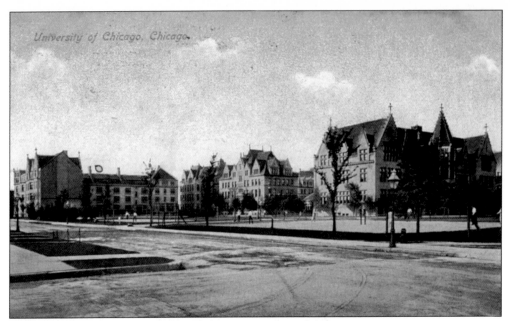

LOOKING NORTHEAST AT ELLIS AVENUE AND EAST 58TH STREET. In this view, tennis courts to the west of Kent Chemical Laboratory occupy the future site of the George Herbert Jones Laboratory (constructed in 1929). Two dormitories, Snell and Hitchcock Halls, appear at the far left. (1909)

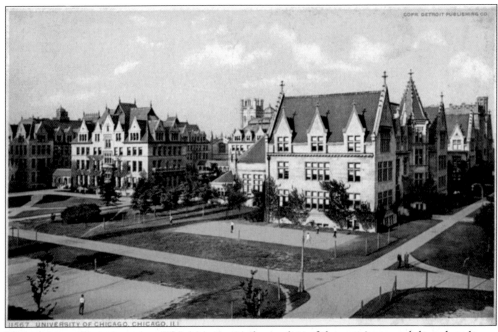

NORTHWEST QUADRANGLE. This view is similar to that of the previous card, but also shows Mitchell Tower, the west end of Hutchinson Hall, and the Botany rooftop greenhouse in the center. To the left are the Physiology and Anatomy Buildings. (DP)

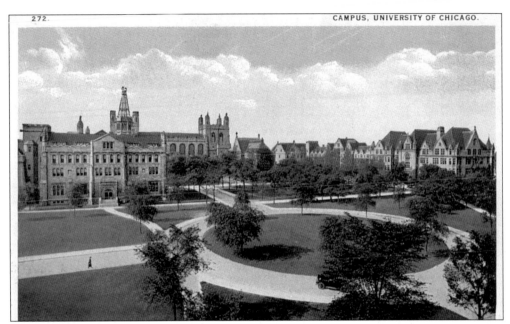

MAIN QUADRANGLE LOOKING SOUTHWEST FROM RYERSON TOWARD HARPER LIBRARY.
This *c.* 1916 view across the main quadrangle depicts, from left to right, Rosenwald Hall (with derrick-like structure atop its octagonal tower), Harper Memorial Library, Haskell Oriental Museum (with skylight in roof), Classics Building, Men's Dormitories, and Cobb Hall. (MRS)

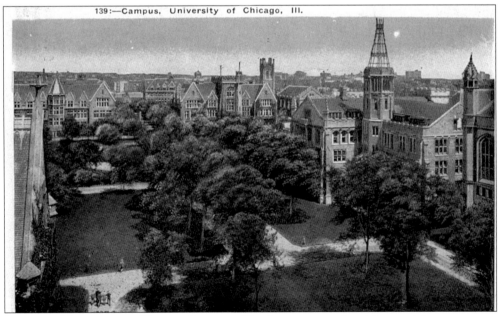

139:—Campus, University of Chicago, Ill.

LOOKING NORTH FROM HARPER LIBRARY. The iron tower at the right stood for many years atop the tower of Rosenwald Hall and was a meteorological station for the U.S. Weather Bureau. It was removed sometime after World War II. (GB-1927)

CHICAGO THEOLOGICAL SEMINARY. The Chicago Theological Seminary was founded in 1855 and was the first institution of higher learning in the city of Chicago. The Seminary moved to Hyde Park in 1914 and, although remaining an independent institution, it belongs to a cluster of schools of theology in Hyde Park which offer courses towards a degree from the University of Chicago's Divinity School. These buildings, constructed between 1923 and 1928, were designed by Herbert Hugh Riddle, and are on East 58th Street and South University Avenue. The west wing holds two chapels, a library, classrooms, and in the basement, the renowned Seminary Co-op Bookstore. Spanning the alley is a second-story bridge/corridor which connected the west wing to a residence hall in the east wing. In the center is Lawson Tower, a gift of newspaper publisher Victor Lawson. It is visited regularly by peregrine falcons. (CLC)

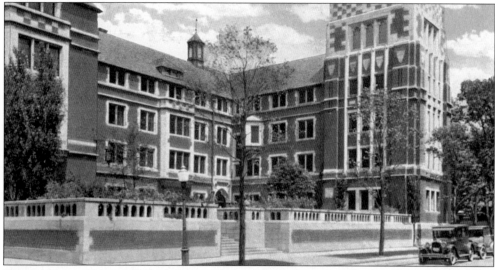

THEOLOGICAL SEMINARY RESIDENCE HALLS. The back reads: "The Residence Halls of The Chicago Theological Seminary at 1164 East Fifty-Eighth Street contain rooms for 100 students and provide every convenience for graduate student life." The Robie House, just across Woodlawn Avenue, is barely visible through the trees on the right. (CT-**1928**)

THEOLOGICAL SEMINARY CLOISTERS. Inside the Theological Seminary are the Clarence Sidney Funk Cloisters, named in honor of the chairman of the Seminary's Finance and Building Committees at the time the buildings were erected. The cloisters surround a courtyard and lead to Thorndike Hilton Memorial Chapel, a tiny chapel "devoted to prayer and meditation." Pieces of historic rock and ancient buildings are embedded in the cloister walls. At the end of this passageway, on the left, is a fragment of Plymouth Rock. (CT-**1928**)

ROCKEFELLER CHAPEL. In 1918, the University hired Bertram Grosvenor Goodhue to design its chapel. Over the next six years the University researched, reviewed, and revised his plans, finally approving them in 1924. The construction took the next three years, and was completed in 1928. The chapel is a solid masonry building which utilizes the Gothic architectural devices of arches and buttresses for support, rather than structural steel. The walls at the base of the tower are eight feet thick. A 72-bell carillon was installed in the tower in 1932; it is the second largest in the world. After the death of John D. Rockefeller in 1937, University Chapel was renamed Rockefeller Chapel. (MRS-1941)

THE ORIENTAL INSTITUTE. Directly across East 58th Street from the Chicago Theological Seminary is the Oriental Institute. It was built in 1931 on the site of the first Quadrangle Club (see p. 71) and was designed by Mayers, Murray and Phillip (the firm of Bertram Grosvenor Goodhue following his death). The building combines Gothic and Art Deco design elements and contains museum galleries, offices, and an auditorium. The Oriental Institute was founded in 1919 by Egyptologist James Henry Breasted for the purpose of studying the "rise and development of civilization" through surveys conducted in the Near East. Artifacts moved from the Haskell Oriental Museum as well as other materials collected in the Near East are displayed in the museum. (CLC)

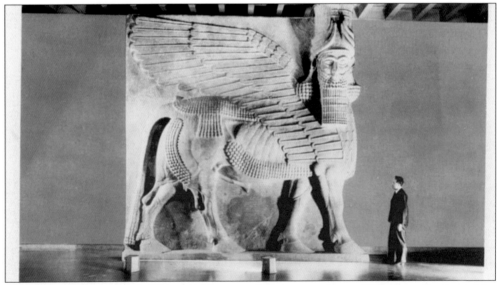

COLOSSAL WINGED BULL. This *c.* 1940 postcard depicts a sculpture from the collection of the Oriental Institute. The creature, an "Iamassu," has the head of a human, the body and ears of a bull, and the wings of a bird. It was one of a pair that once guarded the entrance to the throne room of King Sargon II at Khorsabad, Iraq, and dates from *c.* 721-705 B.C. (AZO)

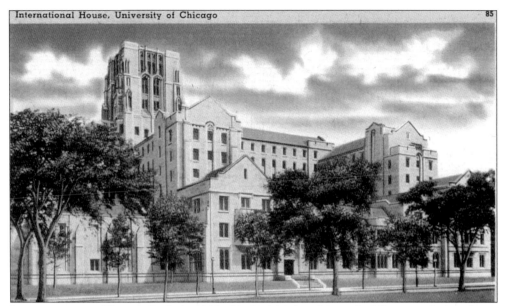

INTERNATIONAL HOUSE. Built in 1932, this Holabird and Root building was designed in a simplified, Art Deco variation of the collegiate Gothic style which has been called "streamlined Gothic." The International House was one of a series built on campuses around the world, with funds provided by John D. Rockefeller Jr., to provide housing and activities for foreign students and visitors. Carvings over the main entrance symbolized the coming together of people from the four corners of the world and inside, flowers and other botanical designs represented countries. Considered out-of-date and said to require prohibitively expensive renovations, in 2000 the building was threatened with demolition. A loud outcry from students, the neighborhood, and the University community-at-large saved the structure. (CLC)

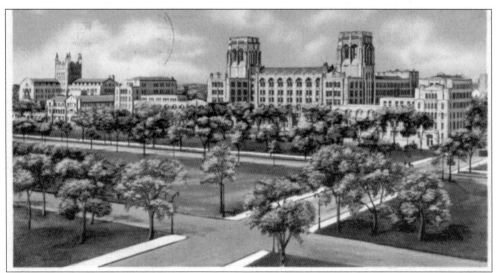

THE HOSPITAL GROUP. The University of Chicago Hospitals opened for classes on October 3, 1927. This view looks northwest across the Midway from Ellis Avenue and East 60th Street and depicts the hospital complex, an area of the campus which has continued to expand ever since the first building was constructed in 1926. (CLC-1937)

91

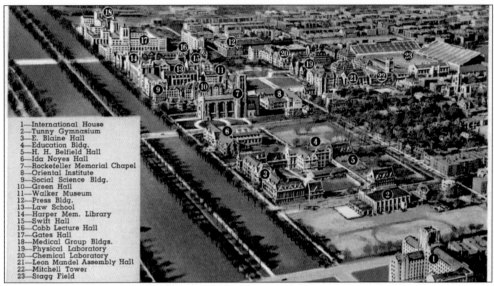

1—International House
2—Tunny Gymnasium
3—E. Blaine Hall
4—Education Bldg.
5—H. H. Belfield Hall
6—Ida Noyes Hall
7—Rockefeller Memorial Chapel
8—Oriental Institute
9—Social Science Bldg.
10—Green Hall
11—Walker Museum
12—Press Bldg.
13—Law School
14—Harper Mem. Library
15—Swift Hall
16—Cobb Lecture Hall
17—Gates Hall
18—Medical Group Bldgs.
19—Physical Laboratory
20—Chemical Laboratory
21—Leon Mandel Assembly Hall
22—Mitchell Tower
23—Stagg Field

AERIAL VIEW OF THE UNIVERSITY OF CHICAGO, LOOKING WEST. This view looks to the northwest across the nearly built-out campus. On the left is the Midway Plaisance and at the top of the card is Washington Park. Of note: Number 23 (Stagg Field) is now the site of Regenstein Library, and the open area between number 4 and number 8, for many years occupied by Woodward Court dormitory, is the site of the new Graduate School of Business. Number 2 should read "Sunny" Gymnasium. (JOS-**1938**)

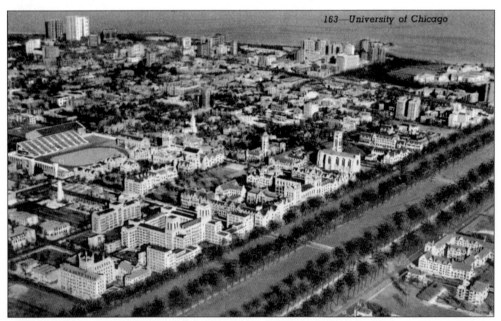

163—University of Chicago

AERIAL VIEW LOOKING EAST. In this view to the northeast, the hospital group is visible in the left foreground. In the lower right corner is Burton-Judson Courts, the first University building constructed south of the Midway. In the background are the business district of Hyde Park and the high-rise hotels and apartment buildings along the lakefront. The low white building in the upper right corner is the Museum of Science and Industry. (CT-**1941**)

92

Four
HYDE PARK HOTELS

"It is only of recent years and perhaps with not quite the same degree of assurance that outsiders have begun to hear of and realize the claims of Chicago as an ideal summer resort, when as a matter of fact too much can hardly be said on this point. In all America there is no big city where one can play and rest so comfortably during a summer vacation, and at the same time learn so much without really going to school, as here in Chicago . . . One may obtain accommodations in any one of the several hotels among the very finest in the country. Within a mile north or south of here is a good boarding house district while both on the North and South Sides near the lake and out from the bustle of the center of the city are a number of fine family hotels." (*Guide to Chicago*, 1909)

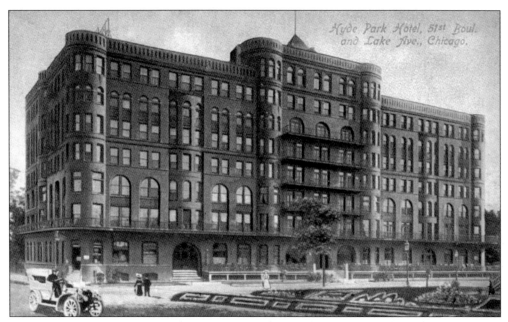

HYDE PARK HOTEL. This hotel was owner Paul Cornell's second Hyde Park Hotel. It was built between 1887 and 1890 on the site of his former home. From the 1893 *Standard Guide*: "Located at Lake Avenue and 51st Street. An elegant family hotel, convenient to the South Parks. One of the largest hotels in the city." The Hyde Park Hotel was a beautiful building with unusual brickwork, curving surfaces, and ornamental ironwork. Unfortunately, it was demolished in 1963. (1911)

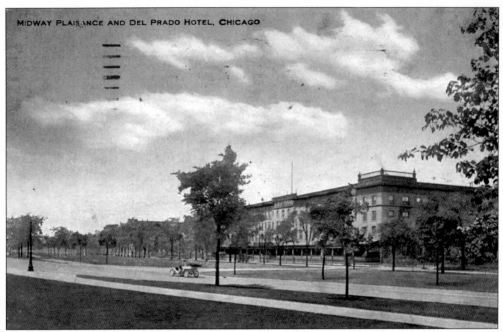

MIDWAY PLAISANCE AND DEL PRADO HOTEL, CHICAGO

HOTEL DEL PRADO. The Hotel Del Prado was built in 1891, in anticipation of the World's Columbian Exposition. Originally called the "Raymond and Whitcomb Grand," it was located on the Midway Plaisance, along 59th Street between Dorchester and Blackstone Avenues. It was an ideal location for Fair visitors, who could step out from their hotel to the Fair's nearest entrance, at 59th and Dorchester, and enter the exotic world of the Midway Plaisance. (VOH-1910)

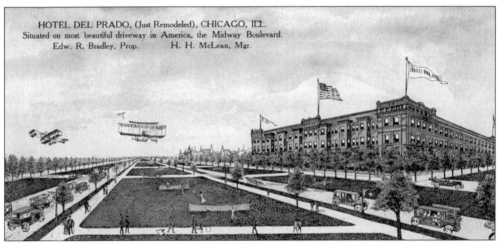

HOTEL DEL PRADO, (Just Remodeled), CHICAGO, ILL.
Situated on most beautiful driveway in America, the Midway Boulevard.
Edw. R. Bradley, Prop. H. H. McLean, Mgr.

HOTEL DEL PRADO. In this view of the Hotel Del Prado, the women's dormitories of the University of Chicago, to the west of the hotel, can be seen in the distance. Many of the activities fancifully illustrated on this postcard were in fact pursued on the Midway Plaisance during this period. Although the Hotel Del Prado was originally intended as a temporary operation, because of its popularity it remained in business until 1930 when it was razed to make way for the University of Chicago's International House. (1911)

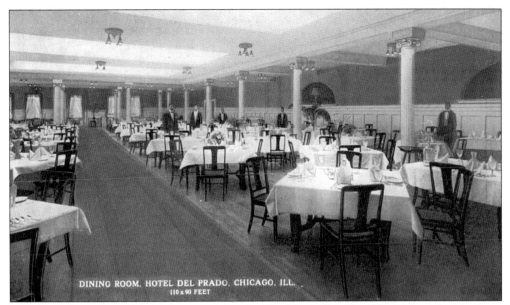

DINING ROOM, HOTEL DEL PRADO, CHICAGO, ILL.
110 x 90 FEET

DINING ROOM, HOTEL DEL PRADO. After the World's Columbian Exposition, the hotel was popular as a residence for many University of Chicago professors and also for temporary lodging of University guests. For a short time it was called the Hotel Barry; in 1895, it became the Del Prado. Pictured here is the dining room and some of its attentive staff. (CT-**1914**)

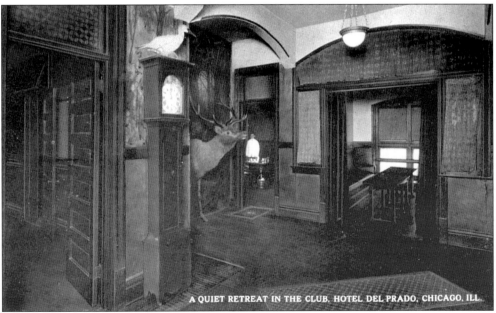

A QUIET RETREAT IN THE CLUB, HOTEL DEL PRADO, CHICAGO, ILL.

THE CLUB, HOTEL DEL PRADO. The University of Chicago's faculty club, the Quadrangle Club, held its first meeting in a suite of rooms in the Hotel Barry on February 22, 1894. This clubroom may have been their meeting place. The period's taste in interior décor is apparent in this room, with its mounted elk head, taxidermied bird, and dark rich wall coverings and carpets. (CT)

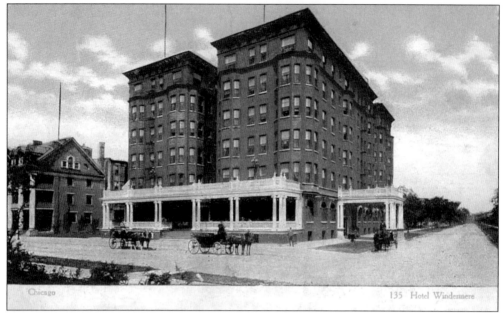

HOTEL WINDERMERE. The Hotel Windermere was built in 1892 and, like the Del Prado, first served as a hotel for visitors to the World's Columbian Exposition. It was located at 56th Street and Cornell Avenue, which was just across the street from the state buildings complex, the "Esquimaux Village," and a Fair entrance gate. (CT-1911)

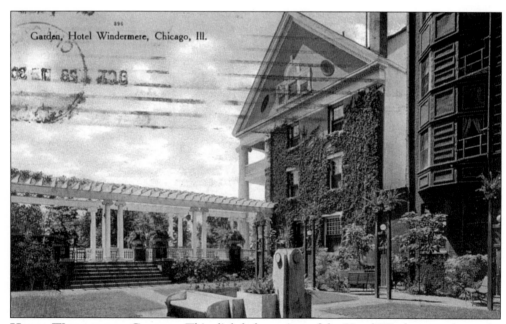

HOTEL WINDERMERE GARDEN. This slightly later view of the Hotel Windermere shows the garden of the hotel, located between the hotel and the building just to the west. As the sender notes, "This is a place I have never seen but it looks attractive surely." (CT-1909)

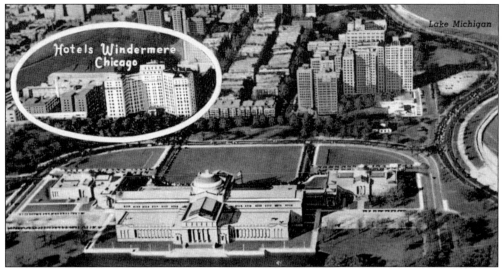

HOTELS WINDERMERE WEST AND EAST. In 1924, a second Hotel Windermere was built. It was designed by the architectural firm of Rapp & Rapp, famous for their elaborate movie theaters such as the Chicago Theatre and Tivoli (now demolished). The new Hotel Windermere (known as Hotel Windermere East) was 12 stories high, contained 200 apartment suites, and 482 hotel guest rooms. There were two underground tunnels (one for guests and one for service) that connected Windermere East and Windermere West. Guests who frequented the Windermere East included John Rockefeller, Phillip Roth, and the Los Angeles Rams and Baltimore Colts football teams. In 1981, the Windermere East was converted into 220 apartment units and in 1982 it was listed on the National Register of Historic Places. The Windermere West was demolished in 1959 and has been replaced by a parking lot. (CT-**1944**)

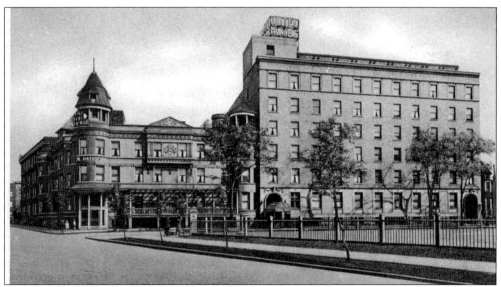

HOTEL HAYES AND ANNEX. The Hotel Hayes was built in 1892, at 64th Street and Woodlawn Avenue, to provide accommodations for World's Fair visitors. The Annex (to the right in this view) was added later by sons John and Frank Hayes. The card advertises "500 Rooms Attractive Rates Dining Rooms and Cafeteria (Popular Prices)." (CT-**1939**)

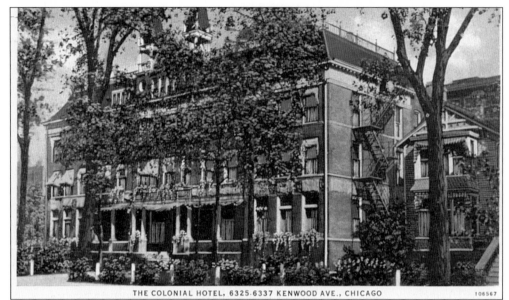

THE COLONIAL HOTEL, 6325-6337 KENWOOD AVE., CHICAGO 106567

THE COLONIAL HOTEL. The Colonial Hotel was another hotel constructed south of the Midway. Located at 6325 South Kenwood Avenue, it operated during the 1893 Fair and was one of the first hotels south of 63rd Street. A 1912 guidebook lists the Colonial Hotel's rate as $1.50 and up. (CT-1933)

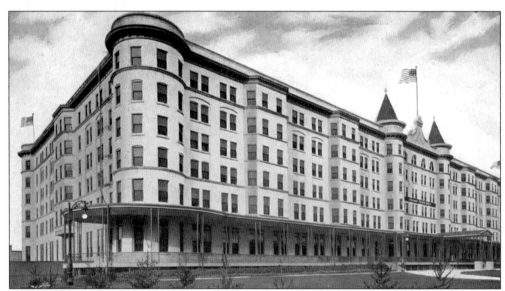

CHICAGO BEACH HOTEL. Among the oldest and most famous hotels in Hyde Park was the Chicago Beach Hotel, constructed in 1892. From *The Standard Guide* (1893): "Location, foot of 51st Street, overlooking Lake Michigan. Warren F. Leland, manager. This beautiful structure has 450 rooms, with 175 bath rooms attached. It is located on the lake beach, only four blocks from the site of the World's Columbian Exposition; fifteen minutes from the heart of the city. . . . It is furnished throughout in solid mahogany. Rates (American) $5.00 per day. The building presents a handsome exterior; the design being in conformity with the established architecture of first-class summer resort hotels. It has charming grounds." (IW)

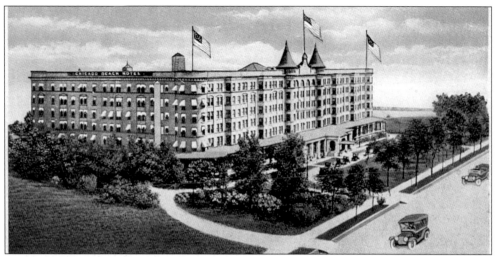

CHICAGO BEACH HOTEL. The Chicago Beach Hotel was perfectly located. The hotel stood between the Illinois Central tracks and Lake Michigan, providing its guests with convenient access to downtown on one side and the pleasure of the beach on the other. In the earlier view (previous page), the hotel's grounds are barely planted. In this view, the landscaping has become more established. (MRS-1918)

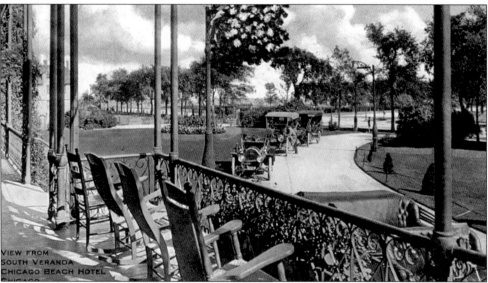

VIEW FROM THE SOUTH VERANDA, CHICAGO BEACH HOTEL. From this south-facing veranda, guests could enjoy the sun and lakeshore breezes. The following quote illustrates the rhetoric used to convince potential tourists that Chicago possessed a pleasant summer climate: "The fault finder and critic who never finds things to suit him, will say to himself . . . "All these things may be very fine, but I am not going to any sweltering hot city of rest and recreation." Right here we must deny his implication regarding the heat of summer in the Windy City and state most positively that Chicago's delightful summer climate is one of her strongest claims to favor as an ideal summer resort. It is not asserted that there are no hot days, but a heated term never lasts more than a few days and is tempered by lake breezes at that, while the general average should suit the most critical." (*Souvenir Guide to Chicago*, 1912) (VOH)

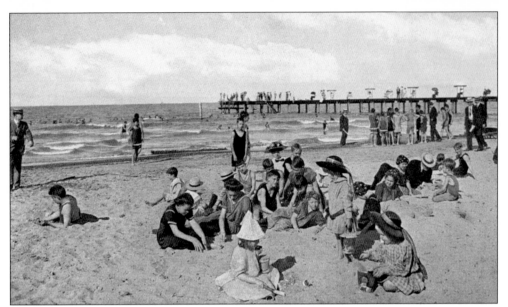

BATHING BEACH AND PIER, CHICAGO BEACH HOTEL. Guests of the Chicago Beach Hotel could enjoy the sand and water of Lake Michigan that was just beyond the hotel. In addition to bathing, guests could also promenade on the pier—a drier and more modest way to experience the lake. (VOH)

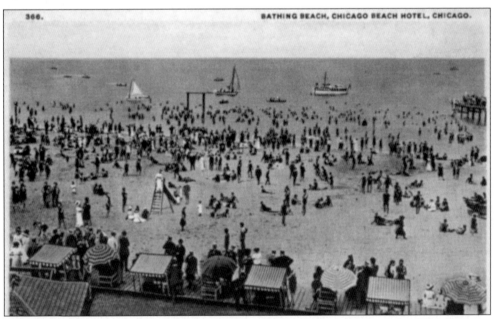

BATHING BEACH, CHICAGO BEACH HOTEL. The caption on back reads: "The Chicago Beach Hotel is located at 51st Boulevard, the Bathing Beach extending south, fronting the Hotel. Yachting, canoeing and bathing, plenty of fresh air and lake breezes, make this an ideal summer home for vacationists." In the 1920s, the hotel lost its beach frontage due to a landfill project which moved the shoreline eastward and led to the creation of South Lake Shore Drive, Burnham Park, and Promontory Point. (CLC)

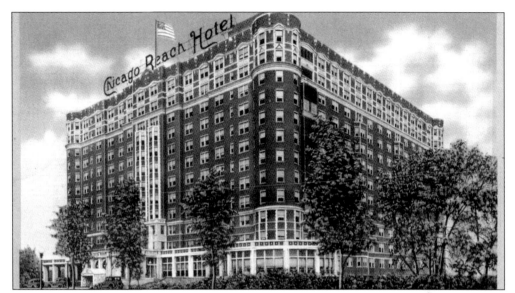

CHICAGO BEACH HOTEL ADDITION. A second building was constructed in 1921, immediately east of the original Chicago Beach Hotel, on what is now the site of Regents Park South. During World War II, the newer L-shaped hotel served in a military capacity. Caption on the back reads: "The Chicago Beach Hotel, known as the Gardiner General Hospital and a landmark on Chicago's South side for a half century, has joined the Army Air Forces for the duration of the war. It is now a station hospital for the Army Air Forces Technical Training Command's Chicago Schools, Brig. Gen. Arnold N. Krogstad, commanding. Long the center of South Shore activities and once nearly as famous as Niagara Falls as a mecca for honeymooners, the 600 room hotel now provide hospitalization facilities for students training as radio operator-mechanics at the Army Air Forces Technical School in Chicago." The hotel was razed in the late 1960s. (MRS)

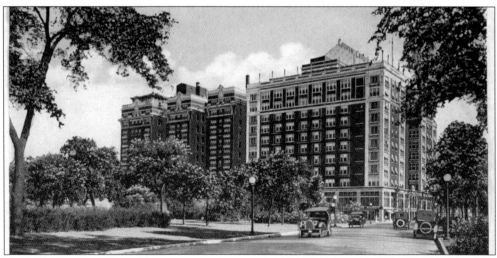

HYDE PARK BOULEVARD, LOOKING SOUTH TOWARD 53RD STREET. Two hotels were constructed at the lakeshore along 53rd Street within a year of each other: The Sisson, on the left and the Cooper-Carlton, on the right. This postcard is unusual because both hotels are shown. The promotional postcards for each hotel usually omitted the neighboring competitor. (GB)

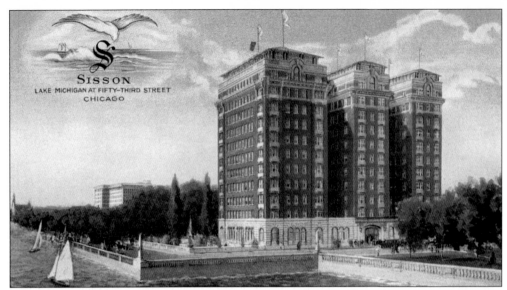

THE SISSON. The Sisson was the first of the two hotels built beside each other on 53rd Street. It was constructed in 1917 on the site of Paul Cornell's first (1857) Hyde Park Hotel, which had been destroyed by fire in 1879. Excluding the tall World's Columbian Exposition buildings, the Sisson was the first high-rise on the south side of Chicago. Visible to the left of the Sisson are the Shoreland Hotel and at the water's edge in the distance, the German Building in Jackson Park. Caption on back reads: "Sisson: Luxurious Detached Homes, Two to Six Rooms. Beautiful Sun Garden and Terrace atop. Delightful Dining Room at water's edge. Sunlit Kitchen adjoining. Unexcelled cuisine and service—Ten minutes along lake front to business center. 375 Hyde Park trains daily." (MRS)

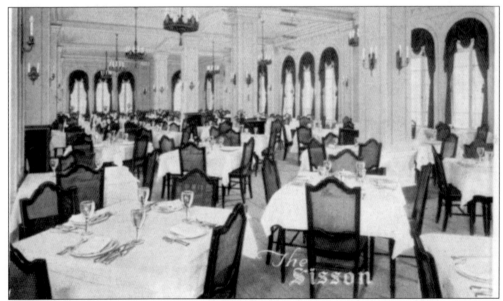

THE SISSON DINING ROOM. Guests of the Sisson enjoyed a view of Lake Michigan while they dined. Caption on back reads: "The privacy of a beautiful home with the service of a most luxurious hotel." (LM-1919)

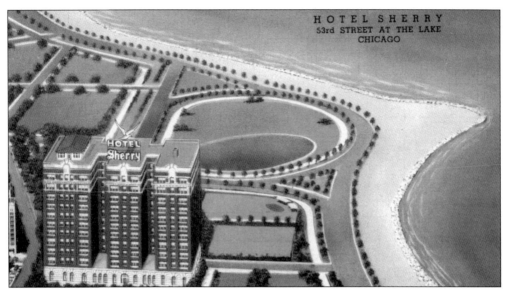

HOTEL SHERRY. The Sisson was later known as the Hotel Sherry, and this view shows how the shoreline was changed by the landfill projects that moved the shoreline eastward. (Compare to view of the Sisson on previous page.) The depiction of the shoreline may not be entirely accurate, however, considering the liberties taken by the artist with regard to the hotel. Not only is the Cooper-Carlton missing, the Sherry occupies the site of the Cooper-Carlton, it appears gigantic compared to the East End Park Hotel to its left, and it has been turned around so that the main facade is facing south! The Sherry, now known as the Hampton House, was for many years the residence of Chicago mayor Harold Washington. (CT-**1950**)

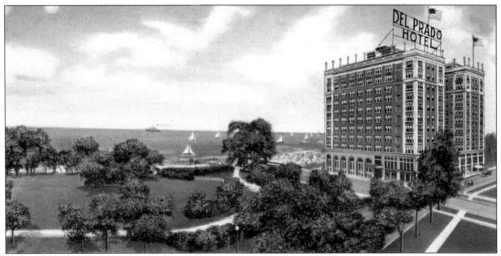

HOTEL DEL PRADO (COOPER-CARLTON). The Hotel Del Prado (formerly the Cooper-Carlton, and not to be confused with the earlier Hotel Del Prado on the Midway Plaisance) was designed by Henry Newhouse and built in 1918. A Native-American theme pervades both the interior and exterior of the building and its unusual terra cotta ornamentation on the façade includes detailed heads wearing feathered headdresses. At one time it regularly hosted visiting American League teams in town to play the White Sox. The building is listed on the National Register and currently houses the Hyde Park Art Center and 198 apartment units. (CT-1945)

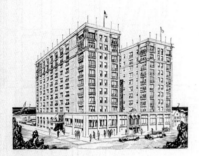
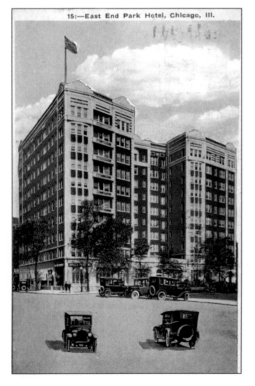

15:—East End Park Hotel, Chicago, Ill.

HOTEL DEL PRADO SOUVENIR MAP. During the 1933-34 Chicago World's Fair, guests of the Hotel Del Prado were given complimentary maps, discounted Fair tickets, and could catch a "World's Fair Bus" at the door of the hotel. The southern-most entrance to the Fair, at 37th Street, was a five-minute ride away. (RFC)

EAST END PARK HOTEL. Completed in 1923, the East End Park Hotel was built at the corner of 53rd and Hyde Park Boulevard, directly northwest of the Cooper-Carleton. The building is still standing and is listed on the National Register of Historic Places, partly due to the architect William P. Doerr's imaginative use of angled corners as a solution to the site's irregular shape. (GB-1927)

104

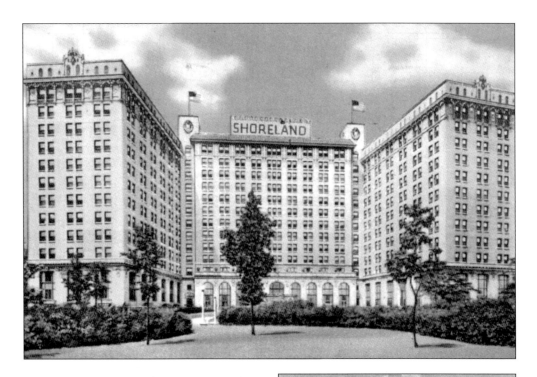

HOTEL SHORELAND. The massive Hotel Shoreland was built in 1925-26 and originally contained 1,000 rooms, a bowling alley, and two ballrooms. At that time it was Chicago's third largest hotel and was a popular location for weddings, private parties, and dances. After a period of decline it was purchase by the University of Chicago in 1974, was converted into 313 apartments, and is currently used by the University as a dormitory. It too is listed on the National Register of Historic Places. Architect: G.H. Gottschalk. (CT-1950)

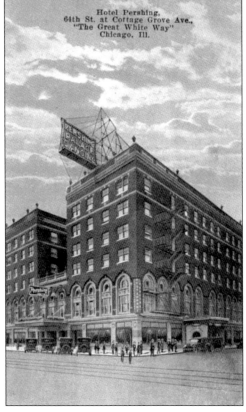

HOTEL PERSHING. The Hotel Pershing was located on Cottage Grove Avenue at East 64th Street, convenient to Woodlawn attractions such as the Trianon Ballroom, White City, and Tivoli Theater. Note the Cottage Grove streetcar tracks in foreground. Caption on back reads: "DISTINCTION: Distinction is achieved not by being merely different, but by being better, finer. The traveler may look forward with pleasure to his stay at the HOTEL PERSHING, 'On The Great White Way.'" (ECK-1927)

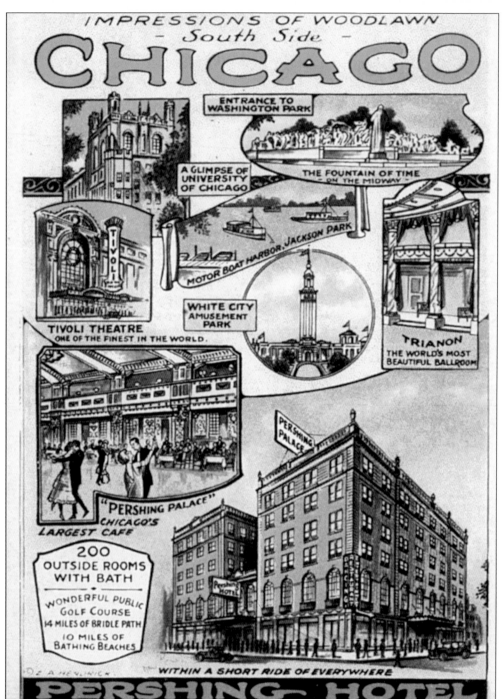

PERSHING HOTEL. Caption on back reads: "THE GREAT WHITE WAY of Chicago—63rd and Cottage Grove Avenue. All railroads entering Chicago, excepting five, stop at Sixty-third Street. Great amusement and theatre center, restaurants, retail shops, department stores, parks, the University of Chicago and Lake Michigan beaches make Woodlawn the garden spot of America. STOP AT THE PERSHING!" (CT-**1924**)

Five

AMUSEMENT PARKS
AND OTHER
PLEASURE GROUNDS

"Chicago has two classes of parks: the public recreation parks which are free to all, and the amusement parks, which are enclosed grounds to which an admission is charged. These latter contain attractions of various kinds, such as roller coaster, shoot-the-chutes, laughing galleries, scenic railways, etc. to each of which a separate admission of from 5 to 25 cents is charged. General admission to the grounds, in Chicago, is almost universally 10 cents. It is entirely optional with the visitor, after paying the general admission fee, whether he visit the various side shows. There are free band concerts, afternoon and evening, in the open air. Once inside the grounds one may remain as long as desired. From the very nature of these amusement parks they cease their activities with the advent of cold weather, except in a few instances where an enclosed roller skating rink is kept open all winter." (*Souvenir Guide to Chicago*, 1909)

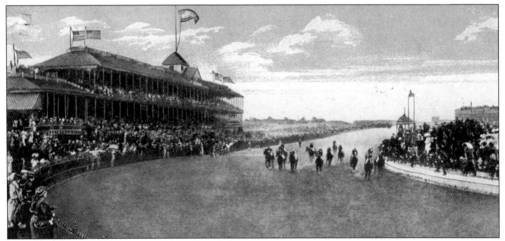

DERBY DAY AT WASHINGTON PARK RACE TRACK. Washington Park Race Track was the first large amusement facility in the Hyde Park area. It was located one block south of Washington Park and occupied 80 acres of land between Grand Boulevard and Cottage Grove Avenues, and 61st and 63rd Streets. The track and elegant clubhouse were built in 1883 and were considered the finest in the United States, even the world. Designed by Solon S. Beman, the grandstand could seat 10,000 people, and the clubhouse had richly appointed parlors, dining rooms, sleeping rooms, and observatories. In about 1910, the racetrack was permanently closed, partly due to the efforts of the Hyde Park Protective League, an association that worked to maintain Hyde Park's prohibition laws and restrict gambling. (PS-1906)

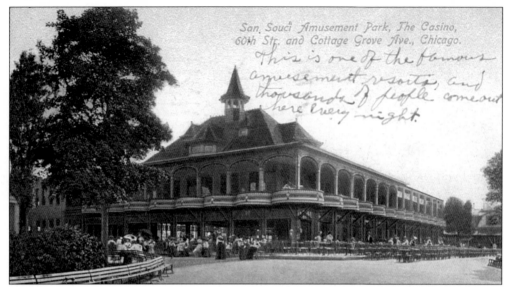

San Souci Amusement Park, The Casino, 60th Str. and Cottage Grove Ave., Chicago.

This is one of the famous amusement resorts, and thousands of people come out here every night.

THE CASINO AT SANS SOUCI AMUSEMENT PARK. Adjacent to Washington Park Race Track was an amusement park called Sans Souci. The initial construction of Sans Souci began in 1898 at the southern edge of Washington Park (between Cottage Grove and Langley Avenues and 60th and 61st Streets). Park developers set out "to build up an amusement enterprise similar to Old Vienna at the World's Fair," and patterned their park after the popular Old Vienna exhibit on the Midway at the World's Columbian Exposition. This casino and a pavilion were among the first buildings erected. (1909)

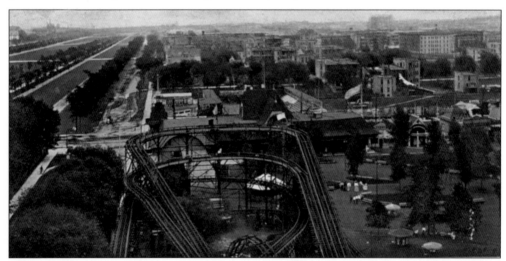

VIEW EAST FROM THE SANS SOUCI ROLLER COASTER. In response to competition from White City, a rival amusement park that opened nearby in 1905, Sans Souci added attractions such as this roller coaster, built in 1906. Later a skating palace, theater, movie house, and bandstand were constructed but to no avail; with the closing of Washington Park Race Track and continued competition from White City, Sans Souci was forced to close in 1912. Of interest in this view: a swampy Midway Plaisance on the left, a blur produced by a passing streetcar on the Cottage Grove line, flags and a clothesline flapping in the wind, and the entrance pavilion to Sans Souci seen through the end of the roller coaster structure. (BS-1906)

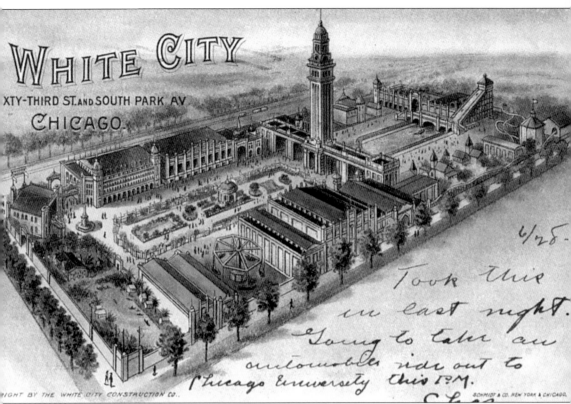

Handwritten note on image:
6/25.
Took this in last night. Going to take an automobile ride out to Chicago University this P.M.

WHITE CITY AERIAL VIEW. The White City was first opened on May 27, 1905. Billed as the largest park in the United States "dedicated to merriment and mirth," one million dollars were spent to create the dazzling grounds, buildings, and rides intended to bring back memories of the beloved World's Fair of 12 years earlier. In this early aerial view, the White City entrance pavilion is the diagonally set building in the upper left (northeast) corner of the grounds. Upon entering the park visitors would first encounter the North Plaza with its sunken gardens and bandstand. To the left and right of the plaza were wooden boardwalks which allowed one to stroll the park while encountering the various rides and attractions. After passing White City's landmark, the Electric Tower, in the center, visitors would arrive at the south end of the park where one of the most popular attractions, Fighting the Flames, was located. In this view it appears just above the water basin on the right, in the southeast corner of the grounds. This realistic staging of a hotel fire included dramatic rescues, real automobiles, fire wagons, and triumphant fire fighting. Also at the south end of the park was the Shoot the Chutes slide and basin. The Scenic Railway can be seen snaking along the southeast edge of the park, and the large building in the lower center was the Boat Ride Thro Venice. (S-1907)

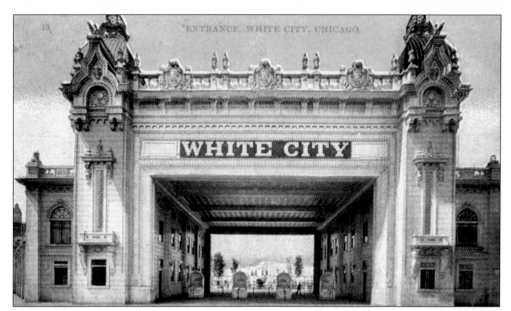

ENTRANCE TO THE WHITE CITY. The White City covered 14 acres between South Park Avenue (now Martin Luther King Jr. Drive) and Calumet Avenue, from 63rd Street to 67th Street. This entrance was just steps away from the South Side Elevated train which allowed easy access to the park from all parts of Chicago. (1910)

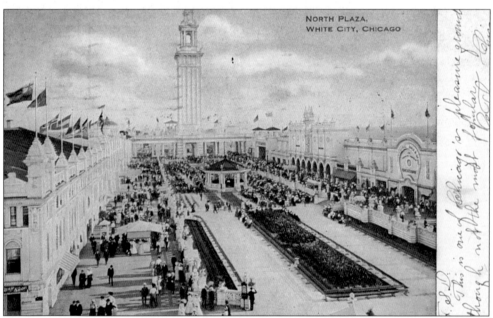

NORTH PLAZA, LOOKING SOUTH FROM WHITE CITY ENTRANCE. White City successfully combined the two most popular elements of the World's Columbian Exposition: the thrilling attractions of the Midway Plaisance and the breathtaking design of the Court of Honor. This view of the North Plaza, with its sunken garden, promenades, encircling white buildings, and colorful flags, must certainly have reminded visitors of the original "White City." (VOH-1908)

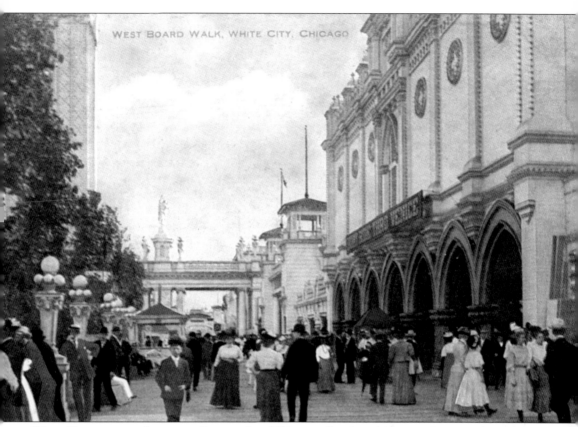

WEST BOARD WALK, WHITE CITY, CHICAGO

WEST BOARDWALK, LOOKING SOUTH. In addition to allowing visitors to circumnavigate the park, the boardwalks were "self-cleaning." Set four feet above the ground and with half-inch gaps between the planks, much of the debris produced each day disappeared by simply falling through the cracks. The attraction to the right on this postcard was Boat Ride Thro Venice, a "romantic gondola ride through moonlit water streets of Venice." (VOH)

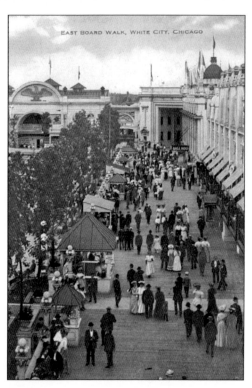

EAST BOARDWALK, LOOKING NORTH. People-watching was an unadvertised attraction at White City. Seeing and being seen were part of the appeal of strolling the boardwalks. On the right is the White City Ballroom (note sign), which could accommodate 1,000 dancers, and, on the left, an outdoor bandstand. (VOH)

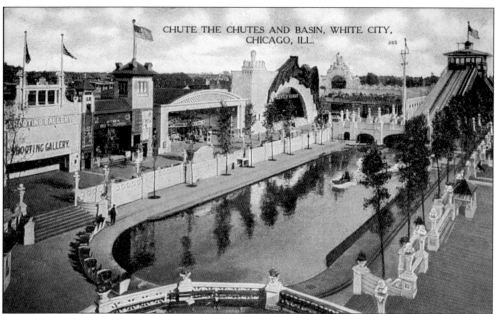

SHOOT THE CHUTES AND SOUTH END OF PARK. This postcard shows many of the attractions located at the south end of White City. Some of them, from left to right, are: Shooting Gallery, Merry-Go-Round, Devil's Gorge, and Shoot the Chutes. A 500-foot-long escalator carried people to the Shoot the Chutes launching platform. Rounding the chute basin in the foreground is the Scenic Railway. (CT-1908)

ELECTRIC TOWER AT NIGHT. The White City dazzled with its white cement buildings outlined with incandescent lights. Illuminated with 20,000 light bulbs and a searchlight, the Electric Tower was the most brilliant of all. Rows of glitter were applied to this card in an attempt to represent the sparkling lights. The sender writes: "Dear friends, Am spending my vacation of ten days with my aunt and am enjoying every moment." (VOH-1908)

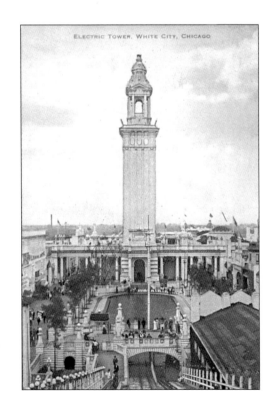

WHITE CITY ELECTRIC TOWER, LOOKING NORTH FROM SHOOT THE CHUTES. The Electric Tower was almost three hundred feet high. Despite its appearance, the structure did not function as an observation tower. It served merely as a landmark and distinctive centerpiece for the park. (VOH)

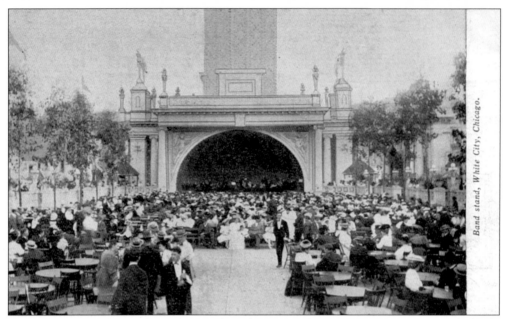

BAND STAND AT WHITE CITY. During the White City's first season, visitors enjoyed the lively music of a famous German band, Banda Rossa, which performed in the outdoor bandstand. Live music performed in the ballrooms, skating rink, and out-of-doors was an important element in the amusement park experience and contributed to the popularity of White City. (BP-1908)

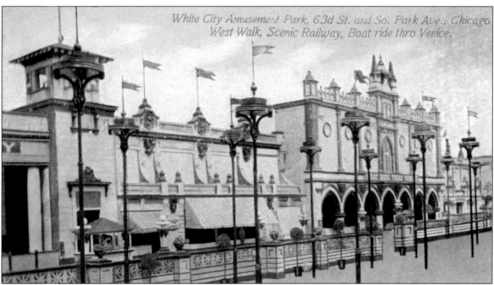

WEST BOARDWALK, LOOKING NORTH. In this view, the Scenic Railway pavilion was at the left, and the arcaded building on the right was the Boat Ride Thro Venice. Although White City was extremely popular, at one point Chicago had five other amusement parks and their competition provided incentive for continual changes and additions. By the mid-1930s however, the effects of the Depression and loss of business to newer nearby venues, especially the Trianon Ballroom, took their toll and the White City was closed by the end of the decade. (FP)

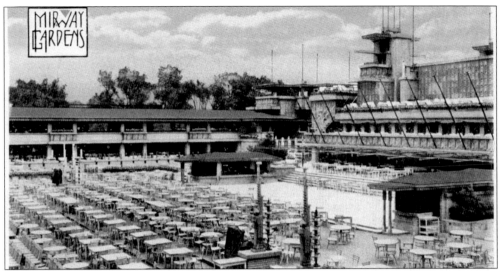

MIDWAY GARDENS, LOOKING NORTHEAST ACROSS SUMMER GARDEN. Another Hyde Park attraction, Midway Gardens was built in 1914 on part of the former Sans Souci site at 60th Street and Cottage Grove Avenue. The architect was Frank Lloyd Wright, and its summer garden, shown here, was an outdoor concert and performance space. Artists such as Anna Pawlova, Benny Goodman, and the National Symphony Orchestra of Chicago performed at Midway Gardens. Interior rooms included a winter garden, public tavern, and private clubroom. Incredibly, the entire complex was constructed in three months. Never financially viable, ownership changed several times, with the property reopening as the Edelweiss Gardens, and finally as Midway Dancing Gardens. In 1929, the building was demolished and a gas station built on the corner. At the back of the lot, however, a remnant wall from Midway Gardens remained for another 20 years. (CT. Lake County (IL) Discovery Museum, Curt Teich Postcard Archives.)

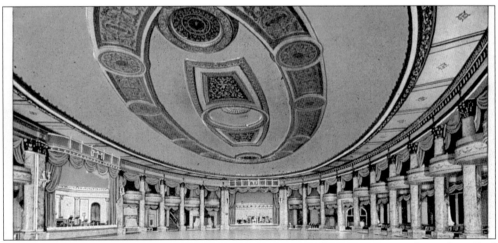

THE TRIANON BALLROOM. The Trianon Ballroom opened in 1922. It was located at 62nd Street and Cottage Grove Avenue, only two blocks away from Midway Gardens. The Trianon, Midway Gardens, White City Ballroom, and just a few other dance halls and hotel ballrooms were the premier venues for the performance of popular music in Chicago at this time. The Trianon's dance floor was enormous; it could accommodate 3,000 dancers. The caption on back proclaims: "In The Whole Universe There Is No Other Place Like Trianon!" (ECK)

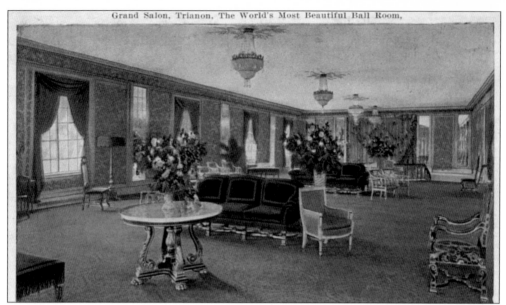

THE GRAND SALON, TRIANON. The spaciousness and elegance of the Trianon were intended to appeal to the middle-class sensibilities of its clientele. The decor may also have been intended to reassure conservative patrons of the respectability of the establishment. Floor monitors kept the dancing "clean," female patrons were prohibited from smoking cigarettes, and the Trianon's whites-only policy prevented the possibility of interracial dancing. (ECK)

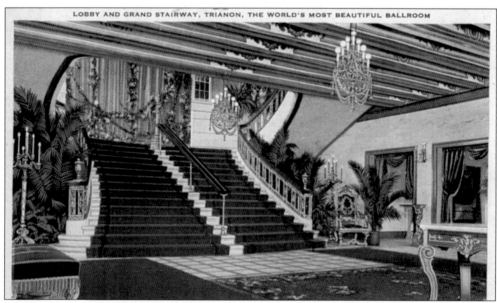

LOBBY AND GRAND STAIRWAY, TRIANON, THE WORLD'S MOST BEAUTIFUL BALLROOM

LOBBY AND GRAND STAIRWAY, TRIANON. Racial exclusivity also extended to performers. Only all-white bands and singers, playing a mild orchestrated style of jazz, were hired to perform at the Trianon; Lawrence Welk was a regular during the 1940s. In the 1950s, these discriminatory policies finally ended; a live recording made during a 1954 performance at the Trianon includes the announcer's frequent references to the ballroom's "new" policy that welcomes "everybody." The building was demolished in 1967. (ECK)

Six

BUILDINGS AND BOULEVARDS

"Chicago is famous for her extensive and highly improved parks and boulevards, few American cities excelling the metropolis of the West in this respect. . . . The great boulevards of the city encircle the metropolis and connect the parks and squares. These great roads, splendidly paved and lined with trees and ornamental lamp posts, throughout the year are the favorite highways of the automobilists and during the summer months are gay with fine equipages of all descriptions."(*Guide to Chicago*, 1909)

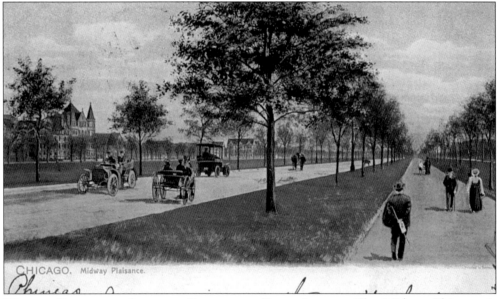

MIDWAY PLAISANCE, LOOKING EAST FROM ELLIS AVENUE. The Midway Plaisance is arguably Hyde Park's most famous boulevard. It was originally designed by Frederick Law Olmsted, as part of his 1871 South Park Plans, to serve as a land and water connection between Jackson Park and Washington Park. Although Olmsted's planned waterway down the middle was never realized, the Midway Plaisance was utilized in another fashion unimaginable to Olmsted in 1871: as the site of the Midway attractions of the 1893 World's Columbian Exposition. The Fair's Midway Plaisance was a huge success and the term "midway" has been used ever since for similar amusement and concession areas at carnivals and fairs. This view of the Midway Plaisance dates from the early 1900s. The turreted women's dormitory, Foster Hall, can be seen at the left. To the right of Foster Hall is the President's House, and further right, other University of Chicago buildings. (RTS-1907)

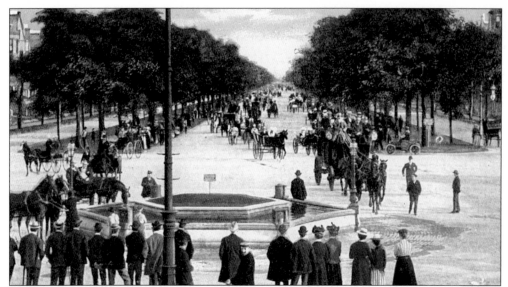

CARRIAGES ON GRAND BOULEVARD AT 35TH STREET. Although not a Hyde Park scene, this postcard has been included because it illustrates the popularity of the carriage circuit that took Chicagoans from downtown, via Grand Boulevard, Oakwood Avenue, and Drexel Boulevard, to and from Washington Park. The following entry is from the 1893 *Standard Guide*: "Grand Avenue: The western entrance to Washington Park; 198 feet in width; beginning at Thirty-fifth street and entering the park at its northwestern angle. Is bordered by a double colonnade of elms and strips of sward. The road-bed is perfect for driving [carriages]. On the western side is a strip reserved for speeding fast horses. It is one of the most fashionable drives in the city. Following up the avenue connecting with Grand Boulevard you are carried past the "Retreat" and on to the Washington Park race-track. By keeping on the same course you may return by the flowerbeds and back via Drexel Boulevard." (SHK)

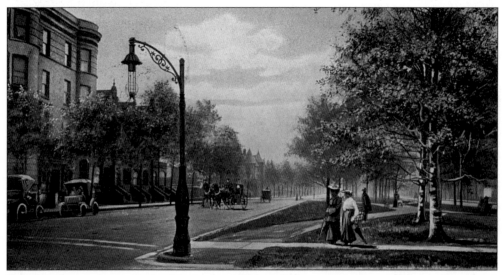

DREXEL BOULEVARD. Beginning in the 1880s and for many years to follow, Grand and Drexel Boulevards were lined with fashionable mansions. Drexel Boulevard featured a center strip that was beautifully landscaped with floral displays. (RTS)

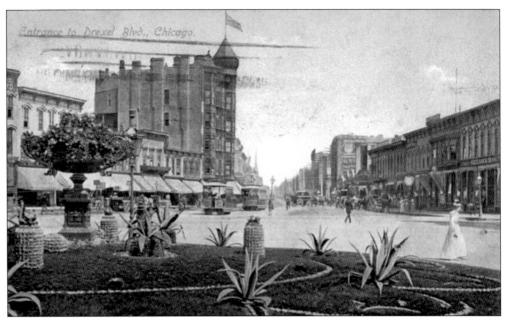

ENTRANCE TO DREXEL BOULEVARD AT OAKWOOD AND COTTAGE GROVE AVENUES. In this view, probably looking north on Cottage Grove Avenue, the commercial nature of the area is quite apparent. Signs identify "Dry Goods" and "Undertaking" businesses, and billboards advertise "Watches, Diamonds, Silverware" and "Wallpaper, Wholesale and Retail, Paints." Note approaching cable cars. (FP-1909)

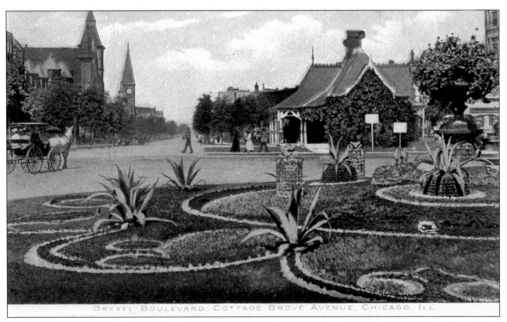

INTERSECTION OF DREXEL, OAKWOOD AND COTTAGE GROVE AVENUES. Looking in another direction from the intersection depicted on the previous card, this view includes an old house known as "The Cottage" where one could rent a phaeton carriage for a drive through Washington Park.

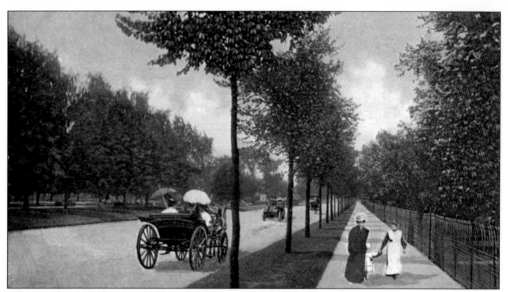

PROMENADE ON DREXEL BOULEVARD. Hyde Park's attractiveness to city-dwellers tired of mud and congestion can be understood when looking at views such as this. The trees, grass, and spacious boulevards and building lots were appealing to the upper class that built homes along the grand boulevards and in Kenwood, or simply enjoyed the respite the area provided on Sunday drives to Washington Park. (FP-1911)

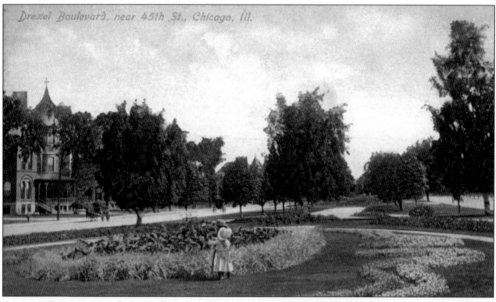

FLORAL PLANTINGS ALONG DREXEL BOULEVARD, NEAR 45TH STREET. Drexel Boulevard ". . . is a double driveway, 200 feet wide for its entire length . . . [and] . . . through the center is a wide strip of sward, covered here and there with beautiful shrubs, rose bushes and mounds. Upon the latter, which are interspersed with flower-beds of beautiful design, appear, during the summer season, unique figures wrought from flowers and foliage, and which attract thousand of sightseers annually." (*Standard Guide to* Chicago, 1893) (AH)

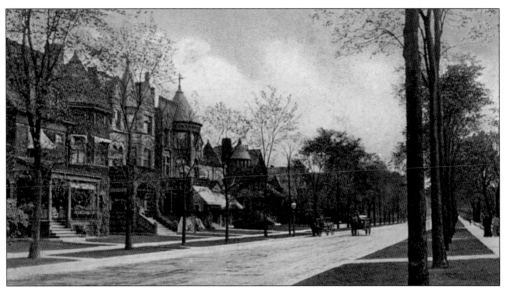

WOODLAWN AVENUE, LOOKING SOUTH FROM 47TH STREET. The street depicted here is in present-day Kenwood and the houses in the left foreground no longer exist. The two homes to the left of the carriages, however, are still standing. The closer one, 4729 South Woodlawn, was constructed before 1887 and was once the home of shoe magnate Milton S. Florsheim. (AH-1908)

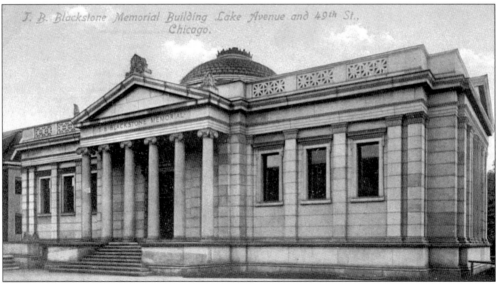

BLACKSTONE MEMORIAL LIBRARY. The Blackstone Library was modeled after the Merchant Tailors Building, a small domed building at the World's Columbian Exposition, which in turn was patterned after Ionic structures on the Acropolis. Though dwarfed by the Illinois Building beside it, the Merchant Tailors Building was considered one of the jewels of the exposition. The architect for both the Merchant Tailors Building and the Blackstone Library was Solon S. Beman, who was commissioned by Mrs. Blackstone to create a library in memory of her recently deceased husband. The building was completed in 1902 and continues to operate today as the Blackstone Branch of the Chicago Public Library. (1911)

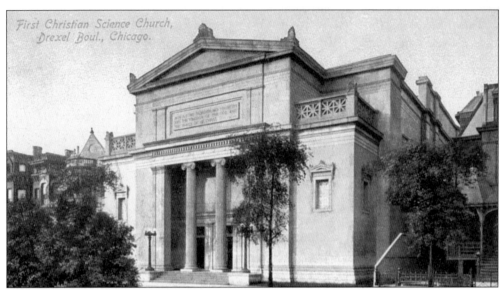

FIRST CHRISTIAN SCIENCE CHURCH. Another design by Solon S. Beman, the First Christian Science Church is located at 4017 South Drexel Boulevard and was built in 1897. Beman's choice of a Classical Greek design was well received and this distinctive church became a prototype for many Christian Science churches constructed in the years that followed. (1908)

HOME FOR INCURABLES. The Chicago Home for Incurables was a hospital complex on Ellis Avenue between 55th and 56th Streets. Many of its patients suffered from paralysis. "[Patients] are provided with invalid chairs, which they can propel at pleasure about their rooms or through the long corridors out upon the wide verandas. There are comfortable seats and inviting hammocks and a perspective of lawn and bright flowers which means much to feeble eyes and limbs. There is a parlor upon every floor . . . a commodious reading-room, and the men have a smoking-room where they may indulge to their hearts' content in the use of their favorite brands" (*Standard Guide to Chicago,* 1893). The Home for Incurables was eventually absorbed by the University of Chicago; Young Hall is the only structure remaining. Note the gentlemen in wheelchairs just inside gate. (ECK-1911)

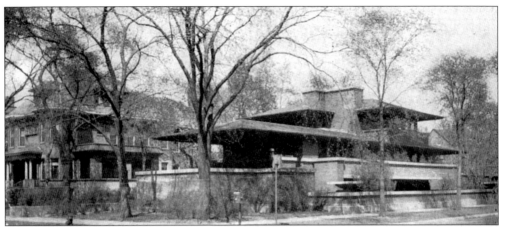

WOMEN'S RESIDENCE HALLS, CHICAGO THEOLOGICAL SEMINARY (ROBIE HOUSE AND GOODMAN HOUSE). For almost 30 years the Robie House served as a residence hall, classroom, and refectory for the Chicago Theological Seminary, located directly across Woodlawn Avenue from the Robie House (see p. 88). The house, built in 1909–1910, was designed by Frank Lloyd Wright for William Robie. In 1926, the house and its contents were purchased by the Chicago Theological Seminary, with an eye on future development of the site. The Seminary also purchased the adjacent Goodman House at 5753 Woodlawn, visible to the left in this view, which it eventually demolished in 1958 and replaced with a modern dormitory. In 1957, when plans to raze the Robie House became public, supporters came to its defense including Mr. Wright himself, who remarked in typical fashion, "It all goes to show the danger of entrusting anything spiritual to the clergy." In 1963, the University of Chicago acquired the property. It is managed by the Frank Lloyd Wright Preservation Trust and is currently undergoing a major restoration. (1929)

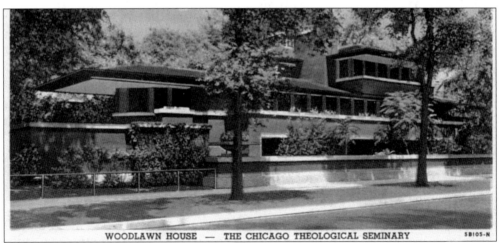

WOODLAWN HOUSE — THE CHICAGO THEOLOGICAL SEMINARY 5B105-N

WOODLAWN HOUSE, CHICAGO THEOLOGICAL SEMINARY (ROBIE HOUSE). The Robie House was one of the last buildings designed by Frank Lloyd Wright from his Oak Park office, and one of his final Prairie houses. With this building Wright also reached the apex of his Prairie period when he employed all of the Style's hallmarks—the horizontal planes, overhanging eaves, art glass, and arrangement of interior spaces—with a boldness and elegance that continues to astonish. (CT-1945)

FORTY-SEVENTH STREET AND COTTAGE GROVE AVENUE IN 1888. This building is identified as the residence of Thomas Sheehan. Although it's not clear who Mr. Sheehan was, the view is interesting because it illustrates the rural quality still found in the area as late as 1888. Note the open fields and natural woodland in the background. (VOH-Photo by James H. Smith)

Lexington Avenue Baptist Church,
Woodlawn, Chicago, Ill.

LEXINGTON AVENUE BAPTIST CHURCH. Known today as the Woodlawn Baptist Church, the church depicted here is located at the southeast corner of University Avenue and 62nd Street. A plaque states that the church was founded in 1890; this building was erected in 1902. (UP)

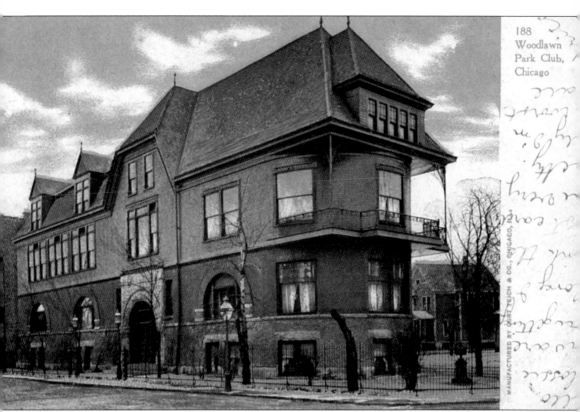

WOODLAWN PARK CLUB. The Woodlawn Park Club was a social organization founded in 1886. The narrow clubhouse stood on the southwest corner of Woodlawn Avenue and 64th Street, on a triangular lot created by the angling Minerva Avenue. The building was destroyed by fire in 1919 and the lot is empty today. The three-story building that appears to the left of the Woodlawn Park Club, however, is still standing. (CT-1908)

MIDWAY PLAISANCE, LOOKING NORTHEAST FROM 60TH STREET. In the foreground of this postcard is the Washington Park terminus of the Midway Plaisance. Buildings of the University of Chicago appear above. The view was part of a larger panoramic photograph taken from the top of the Sans Souci Roller Coaster at Cottage Grove and 60th Street and, in fact, fits together perfectly with the Sans Souci Roller Coaster card on page 108. The small figure at the right of this card appears on the left of the Sans Souci card; by joining the two cards one can view the entire Midway and several blocks to the south. (PS)

177—Aerial View, South Shore Drive, Chicago

SOUTH LAKE SHORE DRIVE AT 57TH STREET. Looking south at the 57th Street Beach, this aerial view also shows the end of the east wing of the Museum of Science and Industry on the right, and Jackson Park beyond. Caption on back reads: "One of the 12 Chicago bathing beaches, thronged with merry-makers on every bright sunny day, is shown on the left." (CT-**1941**)

Bibliography

Appelbaum, Stanley. *The Chicago World's Fair of 1893: A Photographic Record*. (1980). New York: Dover Publications, Inc.

Block, Jean F. *Hyde Park Houses*. (1978). Chicago: The University of Chicago Press.

Chicago Association of Commerce and Industry. *A Guide to the City of Chicago*. (1909). Chicago: The Chicago Association of Commerce.

Edwards, Jim. *Chicago's Opulent Age 1870s-1940s*. (2001). Chicago: Arcadia Publishing.

Flinn, John J., comp. *Official Guide to the World's Columbian Exposition*. (1893). Chicago: The Columbian Guide Company.

Flinn, John J. *The Standard Guide to Chicago*. (1893). Chicago: The Standard Guide Company.

Goodspeed, Thomas Wakefield. *A History of the University of Chicago*. (1916). Chicago: The University of Chicago Press.

Grinnell, Max. *Hyde Park Illinois*. (2001). Chicago: Arcadia Publishing.

Hoffmann, Donald. *Frank Lloyd Wright's Robie House*. (1984). New York: Dover Publications, Inc.

Ives, Halsey C. *The Dream City*. (1893). St. Louis: N.D. Thompson Publishing Co.

Kadens, Emily. *The Quadrangle Club*. (1997). Chicago: The Quadrangle Club.

Kruty, Paul. *Frank Lloyd Wright and Midway Gardens*. (1998). Urbana: University of Illinois Press.

Larson, Erik. *The Devil in the White City*. (2003). New York: Crown Publishers.

Mendelsohn, Felix. *Chicago Yesterday and Today*. (1932). Chicago: Felix Mendelsohn.

National Register for Historic Places Inventory-Nomination Forms (Individual buildings and district nominations)

Newton, Norman T. *Design on the Land: The Development of Landscape Architecture*. (1981). Cambridge, Mass.: The Belknap Press of Harvard University Press.

Nute, Kevin. *Frank Lloyd Wright and Japan*. (2000). London: Routledge.

Pridmore, Jay. *Inventive Genius: The History of the Museum of Science and Industry Chicago*. (1996). Chicago: The Museum of Science and Industry.

Rand McNally & Company. *Souvenir Guide to Chicago*. (1912). Chicago: Rand McNally & Co.

Sinkevitch, Alice (Ed.). *AIA Guide to Chicago*. (1993). San Diego: Harcourt Brace and Company.

The University of Chicago. *A Walking Guide to the Campus*. (1991). Chicago: The University of Chicago.

Image Sources

Dates and publishers have been provided with each postcard image when available. Generally the year listed is the postmark date but when the publication year for a postcard is known that has been used instead and is indicated as follows:

1906 = Postmark date **1906** = Publication date.

Publishers:

A	The Acmegraph Co., Chicago
AH	A. Holzmann, Chicago & Leipzig; Alfred Holzman, Chicago
AZO	AZO (real photo post card)
BP	Bodine Photo
BS	B. Sebastian, Publisher, Chicago
CLC	Chas. Levy Circulating Co., Chicago
CP	ColourPicture Publication, Boston/Cambridge, Mass.
CT	CurtTeich & Co., Chicago
CWG	Charles W. Goldsmith, Agent for the U.S.American Lithographic Co. N.Y.
DP	Detroit Publishing Co.; Detroit Photographic Co.
DPS	Davis Photo Service, Chicago
EA	Empire Art Co., Chicago
ECK	E.C. Kropp Co., Milwaukee
FP	Franklin Post Card Co. Chicago
GB	Gerson Bros. Chicago
HA	Henry T. Adams
IW	I Will
JOS	J.O. Stoll Co., Chicago
KK	Koelling & Klappenbach, Chicago
LM	Leon Morgan, Chicago
MRS	Max Rigot Selling Co., Chicago
NS	N. Shure Co. Chicago
NYP	New York Postal Card Co., Chicago
PAP	Photo and Art Postal Card Co., N.Y., Phila., Chicago
PS	P. Schmidt & Co. Chicago
R	Rotograph Co., N.Y.C.
RFC	R.F. Crane Pub.
RTS	Raphael Tuck & Sons, Providence & London
S	Schmidt & Co. New York & Chicago
SHK	S.H. Knox & Co.
SU	Suhling Co., Chicago; Suhling & Koehn Co. Pub. Chicago
UC	University of Chicago Bookstore
UL	The Ullman Mfg Co New York
UN	UNCO Trademark
UP	United Post Card & Novelty Co., Chicago
VOH	V.O. Hammon Publishing Co., Chicago; also Chicago & Minneapolis
WN	Western News Company Chicago